CONCEPTUAL ART

*03
45

CONCEPTUAL ART
CONCEPTUAL ART
CONCEPTUAL ART
CONCEPTUAL ART
CONCEPTUAL ART
CONCEPTUAL ART
CONCEPTUAL ART
CONCEPTUAL ART
CONCEPTUAL ART
CONCEPTUAL ART
CONCEPTUAL ART
CONCEPTUAL ART
CONCEPTUAL ART
CONCEPTUAL ART
CONCEPTUAL ART
CONCEPTUAL ART
CONCEPTUAL ART
CONCEPTUAL ART
CONCEPTUAL ART
CONCEPTUAL ART
CONCEPTUAL ART
CONCEPTUAL ART
CONCEPTUAL ART
CONCEPTUAL ART
CONCEPTUAL ART
CONCEPTUAL ART

URSULA MEYER, sculptor and writer, is Associate Professor of Art at Herbert H. Lehman College of the City University of New York. She has published articles in *Art News, Arts Magazine, Women in Art*, and *The Print Collectors' Newsletter*. Her work is in the permanent collections of the Finch College Museum, The Brooklyn Museum, The Newark Museum, and the Larry Aldrich Museum.

URSULA MEYER CONCEPTUAL ART

A Dutton Paperback

E. P. DUTTON & CO., INC. | NEW YORK | 1972

Published simultaneously in Canada by
Clarke, Irwin & Company Limited, Toronto and Vancouver

SBN 0-525-47271-1

CONTENTS

INTRODUCTION

"But this isn't *seeing!"*—"But this is seeing!"—It must be possible to give both remarks a conceptual justification.

But this is seeing! *In what sense* is it seeing?

"The phenomenon is at first surprising, but a physiological explanation of it will certainly be found."—

Our problem is not a causal but a conceptual one. . . .

"Is it a *genuine* visual experience?" The question is: in what sense is it one?

Here it is *difficult* to see that what is at issue is the fixing of concepts.
A *concept* forces itself on one. (This is what you must not forget.)
—Ludwig Wittgenstein,
Philosophical Investigations

Intellectualism does not talk about the senses because for it sensations and senses appear only when I turn back to the concrete act of knowledge in order to analyze it. I then distinguish in it a contingent matter and a necessary form, but matter is an unreal phase and not a separable element of the total act. Therefore there are not the senses, but only consciousness.

—Maurice Merleau-Ponty,
Phenomenology of Perception

Finally, and in more general terms, it appears increasingly more difficult to conceive a system of images and objects whose *signifieds* can exist independently of language: to perceive what a substance signifies is inevitably to fall back on the individuation of language: there is no meaning which is not designated, and the world of signifieds is none other than that of language.

—Roland Barthes,
Elements of Semiology

The function of the critic and the function of the artist have been traditionally divided; the artist's concern was the production of the work and the critic's was its evaluation and interpretation. During the past several years a group of young artists evolved the idiom of Conceptual Art, which eliminated this division. Conceptual artists take over the role of the critic in terms of framing their own propositions, ideas, and concepts. "Because of the implied duality of perception and conception in earlier art, a middleman (critic) appeared useful. This [Conceptual] art both annexes the functions of the critic and makes the middleman unnecessary."[1] Sympathizing with this particular viewpoint, certain critics no longer insist upon the absolute division of these functions.[2]

An essential aspect of Conceptual Art is its self-reference; often the artists define the intentions of their work as part of their art. Thus, many Conceptual artists advance propositions or investigations. It is in keeping, then, with Conceptual Art that it is best explained through itself, i.e., through the examination of Conceptual Art, rather than through any assumptions outside of itself. In this sense, this book is not a "critical anthology" but a documentation of Conceptual Art and Statements. "Critical interpretation" tends to frame propositions *different* from the artist's intention, thus prejudicing information. The dependence of the "educated art world" on professional criticism compounds the error.

Why do you waste your time and mine by trying to get value judgments? Don't you see that when you get a value judgment, that's all you have? Value judgments are destructive to our proper business, which is curiosity and awareness.[3]

Conceptual Art makes the ideational premise of the work known, a decided contrast to other contemporary art, which is not concerned with defining the intention of the work, attending (almost) exclusively to its *appearance.* The *IDEA* of the work, which only the artist could reveal, remains hidden, thus becoming everybody's guessing game and/or responsi-

[1] Joseph Kosuth, "Introductory Note by the American Editor," *Art-Language,* Vol. 1, No. 2 (1970).

[2] For example Gregory Battcock, Lucy R. Lippard, John Perreault.

[3] Richard Kostelanetz, "We Don't Know Any Longer Who I Was" (interview with John Cage), *The New York Times,* March 17, 1968.

bility. Under these circumstances there is, indeed, a need for critical interpretation. It gives the gamut of art and art-objects some semblance of coherence and stability, some measure of "objective evaluation," although this process is arbitrary in terms of the artist's intentions. Attending to the critical function itself is the nature of Conceptual Art. There is no further need for critical interpretation of idea and intention already clearly stated.

Conceptual Art completed the break with traditional esthetics that the Dadaists, and notably Marcel Duchamp, initiated. Traditional esthetics could not quite recuperate from the assault of the Ready-mades. Duchamp considered them mainly a satirical gesture toward a dim-witted, elitist establishment. "I threw the *urinoir*[4] into their faces," he wrote later, "and now they come and admire it for its beauty."[5] The critical misunderstanding of his intentions, which troubled Duchamp for decades, still abounds today. The following exemplifies the confusion that results from the division of the functions of critic and artist. In 1961 Duchamp made his intentions in regard to the Ready-mades explicitly clear. "A certain state of affairs that I am particularly anxious to clarify, is that the choice of these Ready-mades was never dictated by any esthetic delectation. Such choice was always based on a reflection of visual indifference and at the same time total absence of good taste."[6] Contrary to Marcel Duchamp's explicit intentions, a recent critique states: "The first ready-made was *Bicycle Wheel* (1913). Duchamp's choice was dictated by common stylistic preferences and the success of the piece depended then—as now—on its stylishness."[7]

Duchamp rejected the myth of the precious and stylish *objet d'art,* a commodity for the benefit of museums and status seekers. His interest turned from the tradition of painting to the challenge of invention.

[4] Reference to *Fountain,* 1917.

[5] Hans Richter, "In Memory of a Friend," *Art in America* (July/August, 1969).

[6] Marcel Duchamp, Statement at a conference during the "Assemblage" Exhibition, Museum of Modern Art, 1961.

[7] Carter Ratcliff, "New York," *Art International* (Summer, 1970).

"Stupid like a painter." The painter was considered stupid, but the poet and the writer were intelligent. I wanted to be intelligent. It is nothing to do what your father did. It is nothing to be another Cézanne. In my visual period there is a little of that stupidity of the painter. All my work in the period before the *Nude* (1912) was visual painting. Then I came to the idea. I thought the ideatic formulation a way to get away from influences.[8]

The notion of the prestigious art-object and the treasured assumption of traditional esthetics proved inadequate. According to Webster's definition "esthetics" is "the study or philosophy of beauty." By this very definition, esthetics as a criterion for art is an assumption whose locus is outside of art. The semantic development of the term "esthetics" is curiously interesting and merits our attention. Esthetic derived from *aisthetikos:* sensitive. *Aisthetikos* evolved from *aisthanesthai:* to perceive. The original meaning of esthetics, sensitive perception, or sensibility, is much closer to contemporary thinking than the mutation of the term. ". . . nothing was authentic except sensibility, and so sensibility became the very substance of my life."[9] Thus Kasimir Malevich described his "liberation from the object" (1913), an issue fundamentally relevant to contemporary art.

"All art after Duchamp," said Joseph Kosuth, "is conceptual in nature because art only exists conceptually."[10] This statement not only summarizes Kosuth's view of all art after Duchamp, it also questions all art before. Taken at face value, it gives the coup de grâce to all "morphological" art of the past (and our accumulated consciousness thereof), refuting at the same time all such contemporary art that depends upon the rationale of traditional art.

Art-propositions referred to by journalists as "anti-form," "earthworks," "process art," etc., comprise greatly what I refer to as "reactive" art. What this art attempts is to refer to a traditional notion of art while still being "avant-garde." One support is securely

[8] Francis Roberts, "I Propose to Strain the Laws of Physics," interview with Marcel Duchamp, 1887–1968, *Art News* (December, 1968).

[9] Kasimir Malevich, *The Non-Objective World,* trans. Howard Dearstyne (Chicago: Theobald, Paul & Company, 1959).

[10] Joseph Kosuth, "Art After Philosophy," *Studio International* (October, 1969).

placed in the material (sculpture) and/or visual (painting) arena, enough to maintain the historical continuum, while the other is left to roam about for new "moves" to make and further "breakthroughs" to accomplish.[11]

Kosuth stresses the idea that the morphology of the art-object, in terms of material and style, vitiates the purity of idea. It could be argued, however, that the many objects in *Information Room*[12] are contradicting Kosuth's dictum of *"art as idea as idea."* *Information Room* displays two large tables covered with books, mostly linguistic philosophy paperbacks, among them Kosuth's various *Investigations.* There are chairs inviting us to sit down and share in the artist's reading. From Kosuth's viewpoint the art of *Information Room* is not to be found in the random arrangement of objects, but in placing them in the art context of his *Investigations.* Said Kosuth (regarding his *Propositions,* 1970): "The art consists of my action of placing this activity (investigation) in an art context (i.e., art as idea as idea)."[13] Art is not in the object, but in the artist's conception of art to which the objects are subordinated. *Information Room* allows us to partake in the artist's *cogito ergo sum.* The exaltation of IDEA and the preference of the ideational over the visual are reminiscent of Plato, whose *Ideas* have surfaced throughout the ages. Yet never before has it been proposed to shape "art after philosophy" to the degree suggested by Kosuth.

Whereas Kosuth emphasizes art-as-idea, Conceptualist Bernar Venet stresses art-as-knowledge. He presents scientific treatises and books; he introduces lecturers—physicists and mathematicians—who speak about their latest discoveries and theorems to an audience largely composed of artists and aficionados. The subject of Venet's work is the documentation of science.

The aspect of documentation has become increasingly

[11] Joseph Kosuth, "Introductory Note by the American Editor," *Art-Language,* Vol. 1, No. 2 (1970).

[12] "Conceptual Art and Conceptual Aspects" Exhibition, The New York Cultural Center, 1970.

[13] "Software" Exhibition, The Jewish Museum, 1970.

important for Conceptual Art. The camera as well as the Xerox machine can be used as dumb recording devices. Conceptual artists—among others On Kawara and Douglas Huebler—have used meaningless, everyday occurrences, maps, snapshots, diagrams as "containers" for their conceptions. In essence On Kawara's work is a continuous documentation of events of his day-to-day life: *I Got Up* is a continuous statement, printed on picture postcards, informing us when and where he gets up every day. On Kawara's ten-volume work *One Million Years* (1970) consists of numbers only, accounting for man's one million years on earth. About his *Code: Eight Quintillion Eight Hundred and Two Quadrillion . . .* (1969), which comprises five pages of "spelled out" astronomical numbers, Kawara said: "This code is easily cracked. You will find many answers which yield one question. I got this question from *MAD Magazine* (Number 128, July, 1969)." He enjoys punning the self-seriousness of artists—"Recreation is more important than creation," he said.[14] In essence, On Kawara's work is a continuing documentation of his day-to-day life.

Supported by photographic documentation and/or live evidence, Hans Haacke's biological, sociological, and information structures investigate the systematic relationships between actual events and conceptions.

Through their performances Vito Acconci, Dan Graham, Bruce Nauman, and Dennis Oppenheim have established certain relationships between physical occurrences and intentions. With photographs and documentation, Oppenheim advances unexpected correlations between competitive physical performances and theatrical events, e.g., his *Energy Displacement—Approaching Theatricality* (1970). Bruce Nauman gives his satirical bent an adequate expression with photos of his facial contortions, grimacing at the "Conceptual Art and Conceptual Aspects" Exhibition (1970). There he also "showed" his piece *Violin Tuned D.E.A.D.* (1969), consisting of a continuous sound-tape, repeating grating noises. These artists have made films and videotapes that document and elaborate their work. Vito Acconci's film *Hand*

[14] On Kawara in conversation with the editor, October 7, 1970.

in Mouth Piece (1970) shows the artist forcing his hand into his mouth, until he has to stop. In Acconci's work, the endurance time of the performer becomes the duration time of the piece and/or film. However, it should be mentioned that film as a medium does not hold the same interest for Conceptual artists that it holds for filmmakers. Said Acconci: "Most of us are not interested in film as film. I personally do not care for setting up scenes and editing."[15] In a certain sense, the artist performing replaces the traditional object of art—that is to say that, in performance, artist and art-object merge.

Conceptual Art emphasizes the elimination of the art-object. Without the interference of objects Sol LeWitt gives a subtle emphasis to actual space through the direct application of his schematic drawings to the gallery wall. Mario Merz's interpretation of Fibonacci's Progressions and Hanne Darboven's[16] Number Constellations stress the mystery of numerical relationships. Mel Bochner's measurement series document and evaluate the space of galleries and museums. Daniel Buren's stripes applied to walls, doors, and billboards create a focused tension within the environment. The *Perspective Corrections* (1969) of Jan Dibbets convey a *trompe l'oeil* effect; geometric configurations superimposed on the landscape are "corrected" for perspective distortions, and parallel lines, instead of converging, stay parallel.

The N. E. THING CO. (Iain Baxter, President) specializes in new modes of perception and Visual Sensitivity Information (V.S.I.). The Company's ACT and ART Departments issue certificates with photo and documentation of Aesthetically Claimed and Aesthetically Rejected Things, ranging in subject matter from icy landscapes to well-stocked supermarkets, from industrial objects to works of contemporary art. Much of Baxter's work is available through documentation in catalogues and books.

Books have become an increasingly important medium for Conceptual Art, often taking the place of exhibitions. They have more permanence than transient shows in galleries. Edward Ruscha's books are strict documentations of what

[15] Vito Acconci in conversation with the editor, October 20, 1970.

[16] Hanne Darboven does not consider herself a "Conceptual artist" and requested that her work not be shown in this context. Conversation with the editor, October 2, 1970.

he perceives; for instance, *Twenty-six Gasoline Stations*[17] consists of photographs of twenty-six gasoline stations between Los Angeles, California, and Groom, Texas. Ruscha does not embellish facts. His photographs are bland, ordinary snapshots. "I don't have any message about subject matter at all. They are just natural facts, that's all they are," commented Ruscha on his gas stations.[18] Lawrence Weiner's book *Statements*[19] records a number of his works. These are concise propositions, succinctly worded; each sentence immediately evokes a picture of the fact referred to, explicit and without metaphor. It was Seth Siegelaub who clarified the relevance of books and catalogues for Conceptual Art.

When art does not any longer depend upon its physical presence, when it becomes an abstraction, it is not distorted and altered by its reproduction in books. It becomes "PRIMARY" information, while the reproduction of conventional art in books and catalogues is necessarily (distorted) "SECONDARY" information. When information is PRIMARY, the catalogue can become the exhibition.[20]

Conventional gallery space is better suited for exhibiting object art than for showing conceptions. Notable exceptions were the Dwan Gallery's annual Language Shows, which displayed a variety of word and language images. A few of these were purely conceptual, others presented the esthetic aspects of letters, words, language. The first exclusively Conceptual Art exhibition, "January 5–31, 1969," showing the work of Barry, Huebler, Kosuth, and Weiner, was arranged by Seth Siegelaub.

The work of Robert Barry demonstrates the progressive elimination of the object. His radioactive installation *0.5 Microcurie Radiation Installation* was buried in Central Park in January, 1969. However, he objected to the tiny isotopes; they were devices, i.e., objects. He then changed to an inert (imperceptible) gas that returns to the atmosphere, continually expanding and changing. Focusing his interest on energy "without object-source," he started to work with telepathy;

[17] New York: George Wittenborn, Inc., 1967.

[18] Douglas M. Davis, "From Common Scenes, Mr. Ruscha Evokes Art," *National Observer*, July 28, 1969.

[19] Ed. Seth Siegelaub (New York: George Wittenborn, Inc., 1969).

[20] Seth Siegelaub in conversation with the editor, September 27, 1969.

his *Telepathic Piece* (1969)[21] is the object's *reductio ad absurdum*. During that year, for the duration of his exhibition, Barry had his gallery (Art & Project in Amsterdam) closed.

The abolition of the art-object, typical for Conceptual Art, eliminates the concern with "style," "quality," and "permanence," the indispensable modalities of traditional and contemporary art. Style, quality, and permanence support the notion that age is a basic consideration for the value of an art-object. "The detachment of art's energy from the craft of tedious object production has further implications," said Robert Morris. "This reclamation of process refocuses art as an energy driving to change perception. (From such a point of view the concern with 'quality' in art can only be another form of consumer research . . .)"[22] From the Conceptual standpoint, material properties and esthetic qualities are secondary and could be dispensed with. The concern with quality and style tends to favor repetition. The Dadaists— notably Duchamp and Picabia—distrusted the repetitive esthetic efforts (of Cubism). Paradoxically, the efforts of the practitioners of an art form tend to wear out the "art." The speed at which modern media dispense information accelerates this process.

The physicist J. Robert Oppenheimer's comment on science applies as well to art: There have been more discoveries during the past few decades than during all the preceding centuries. In *Physics and Beyond,* Werner Heisenberg described how scientists approached the key area of philosophy, the area between mathematics and physics, with the various means of analysis, formulas, experimentation, image, parable, and poetry; the extension of one field into another is conducive to discovery. The trends of scientific discovery apparently parallel developments in art. There is the exploration of other fields—film, performance, poetry, philosophy, science, and technology. There is also the break with tradi-

[21] Seth Siegelaub Exhibition, 1969, at Simon Fraser University, Vancouver, B.C.

[22] Robert Morris, Statement, "Conceptual Art and Conceptual Aspects" Exhibition, The New York Cultural Center, 1970.

tion and the incessant casting about for an entity that one does not yet know. The initial atomic investigation, for instance, proceeded in the absence of any language that could adequately describe what the scientists were looking for.[23] Analogously, the traditional language of art is no longer adequate to questions of Conceptual Art. What has occurred in science, as in art, is that a new form of apperception has been added, which allows for perceiving phenomena that are abstract and/or invisible. However, Euclidean mathematics, just as esthetics, continues to apply to all real things. Though the mode of esthetics changes with the changing time, esthetics is inextricably tied up with objects, no matter how hard the artist tries to declassify them.

Science and art, as well as industry, are vitally affected by the dominating trend for abstraction. Jean-Jacques Servan-Schreiber, the French writer, economist, and politician, expressed boredom with the hardware industries. He referred to a 2" x 2" microcircuit, empowering a 21" television screen: "The more abstract, the more interesting." Mini-electronics, abstractions of abstractions, can be viewed as nervous, cerebral energy in contrast to the muscular power of heavy industry. Conceptual Art is diametrically opposed to hardware art. From a Conceptual standpoint, the highly styled art-object with its built-in permanence has ceased making sense; the most remarkable sculpture of our time, the moon rocket, consumes itself in one trip.

Throughout history, art has been a source of information. Scope and content of information and the manner in which it is framed result in the particular style of a particular period. In ancient Egypt, the birth and death of Pharaohs were depicted on the walls of temples and pyramids. During the Middle Ages and the Renaissance, until the time when the dissemination of information became the prerogative of the printing press, art could not be comprehended in terms of its appearance alone. Art dealt with very specific items of information concerning social facts and events. Since we lack the essential information, our understanding of the art of the

[23] Werner Heisenberg, *Physics and Beyond* (New York: Harper & Row, 1971).

past is greatly handicapped. Even if information could be made available to us, it would have lost much of its relevance. Either contention supports our customary way of appreciating art, past and present, in terms of esthetic enjoyment. This type of appreciation cultivates taste at the expense of sensibility. Without its former *raison d'être* as a source of information, art (and what is "recognized" as art) depends upon: (1) the artist's (arbitrary) choice, (2) the critics' approval, (3) the manipulations of the institutionalized art world. Museums, galleries, and collectors rely upon critical evaluations of art-as-experience and art-as-investment, respectively. Accordingly, the "approved art" (justifiably or unjustifiably) soars in dollar value. The art world hierarchy is a closed system, based on circular reasoning, issuing from and returning to the dichotomy of the creative and critical functions. The quest for authentic art leads away from the marketplace. A noncommercial attitude reinforces the isolation of art from object: no objects, no sales.

"Art-as-Art is a creation that revolutionizes creation and judges itself by its destruction. Artists-as-Artists value themselves for what they have gotten rid of and for what they refuse to do."[24] Since Kasimir Malevich and Piet Mondrian, much of our art is singularly characterized by an intense need for abstraction. Artists abstract whatever is not essentially art. In this sense, then, abstraction becomes synonymous with subtraction. However, Mondrian envisaged the fuller meaning of "abstraction." For him the act of abstracting did not consist solely of "reduction" and/or "removal," but referred at the same time to the *abstract,* in the sense of IDEA (it), the universal rather than the particular. The notion of abstraction as synonymous with subtraction should be reexamined. Whenever any properties of an object are removed, they are immediately *substituted* for by other properties; for example, geometric design substituted for figurative subject matter, color-field painting substituted for geometric design, and so forth. If all deliberate design were to be eliminated, there still would be the thinghood of material. Abstraction in art does not function simply in terms of

24 Ad Reinhardt, "Writings," *The New Art,* ed. Gregory Battcock (New York: Dutton Paperbacks, 1966).

"reduction" as it has been assumed all along. What has been occurring is a process of substitution of visual, i.e., esthetic values. A new set of qualities substitutes for the old one, which is no longer considered "art." This substitutional process was interpreted in terms of "abstraction" (and/or "reduction").

Three of Webster's definitions of the term "abstraction" are relevant to our discussion: (1) "An abstracting or being abstracted; removal." Abstraction, in this sense, refers to the notion of reduction (e.g., Minimal Art, termed "reductive" art). This notion also applies to Anti-form, though the *type* of reduction is quite different. Instead of simplifying the object structurally in terms of "removing" certain particular properties, the very coherence of the object is removed. Yet, the Anti-form work unfinished and dematerialized is still within the sense of an object. Only the *appearance* has changed. Esthetic values have been substituted and, paradoxically, the negation of the object becomes its affirmation. Webster's other definitions of "abstraction" are: (2) "Formation of an idea, as of qualities and properties of a thing, by mental separation from particular instances or material objects." (3) "An idea so formed, or a word or term for it." This sense of "abstract" applies more adequately to the work of the British *Art-Language* group: Terry Atkinson, David Bainbridge, Michael Baldwin, and Harold Hurrell. These artists, together with Ian Burn, and Mel Ramsden, constitute the core of so-called *Analytic Conceptual Art.* Analytic Conceptual Art offers a consistent linguistic elaboration "from an Art and Language Point of View."[25] (Parts of these treatises are published in the magazine *Art-Language.*) In 1967, the *Art-Language* group proposed the use of a theoretical column of air based on an unspecified square-mile location. Some recent work established sets of criteria derived from the examination of certain art situations. For example, the *Lecher System* provides the stimuli necessary for normal viewing behavior, and it also becomes the starting point for a series of theoretical constructs and investigations concerning the function of art. These artists have acknowledged that all contingencies involving objects, be they real or theoretical,

[25] Terry Atkinson, "From an Art and Language Point of View," *Art-Language,* Vol. 1, No. 2 (February, 1970).

pose an obstacle to ideational concern. Hence, they seized upon the fundamental role that language has played in the development of art. Whereas many conceptual artist-writers use language in *support* of art, the English *Art-Language* group have proposed the use of language as the *material* of art. Terry Atkinson then raised the significant question, whether a treatise concerning the essential tenets of Conceptual Art "can come up for the count as a work of Conceptual Art."[26]

Ian Burn and Mel Ramsden also investigated ways in which language could be used as the material of art. *The Grammarian*[27] does not refer to any practical application, but functions as an analysis of its intentions. Emphasis has shifted from the language of an investigation (of art) to the investigation of art-language, thus, evolving a language about language, hence a meta-language.

The redefinition of artwork as syntactical indicates that there may be no limit to that abstractness, and that art's manner of operation can move from the myriad permutations of iconic hardware into a study and application of the category itself, where category is interpreted as being a context of rules and conditions . . .[28]

In a subsequent investigation Burn and Ramsden stressed that the overall ideational development of an artist has more value than any instances of his artwork. The traditional approach, which evaluates an artist according to his art production, has no reference to a strictly dialectical approach to art. The initial move is to stop isolating the artwork from the syntactical place it holds in relation to the artist. An elucidation of this syntax would seem to coincide with and expose the conceptual process and development of the artist. This, then, may be leading toward the consideration of criteria for artists.[29]

Until now, criteria have not related to the artist, but solely to the work of art. For example, Analytic Conceptual Art

26 Terry Atkinson, "Introduction," *Art-Language,* Vol. 1, No. 1 (May, 1969).

27 "Concept Theorie" Exhibition Galerie Daniel Templon, Paris, 1970.

28 Ian Burn and Mel Ramsden, "Stating and Nominating," *VH-101,* No. 5 (May, 1971).

29 The stress on the artist over the work brings to mind Duchamp's remark (to Arakawa, 1964)—"There is a lot of good art around, but hardly any artists."

evolved a set of criteria that led to: (1) the separation of art from contextual dependency, which has been recognized as a mainstay of modern art (the art-object is not "self-supporting"; from Duchamp's icons to Flavin's fluorescents, the "art" depends on the art context that museums, galleries, and professional journals supply)—(2) the isolation of art from any material representation. Although many Conceptual artists consider abstraction in the traditional terms of material reduction, the more radical Analytic Conceptual artists reject material aspects, proposing the functional change of art, i.e., the abstraction of art itself, rather than of any of its particular properties. Conceptual treatises have an ideational logic and/or imagery of their own, which needs to be studied and thought out, requiring the same attention given to the study of the scientific and philosophic disciplines. "In a sense, then, art has become as 'serious' as science or philosophy which doesn't have audiences either. It is interesting or it isn't, just as one is informed or isn't."[30] In taking art as seriously as scientists take science, artists refuse to play the game of art world fads. They are declining society's role assumption of "showman," unwilling to subject themselves to name-fame competition. The shift from object to concept denotes disdain for the notion of commodities—the sacred cow of this culture. Conceptual artists propose a professional commitment, that restores art to artists, rather than to "money vendors." The withdrawal of art into itself may be its saving grace. In the same sense that science is for scientists, and philosophy is for philosophers, art is for artists.

Ursula Meyer

[30] Joseph Kosuth, "Introductory Note by the American Editor," *Art-Language*, Vol. 1, No. 2 (1970).

CONCEPTUAL ART

VITO ACCONCI

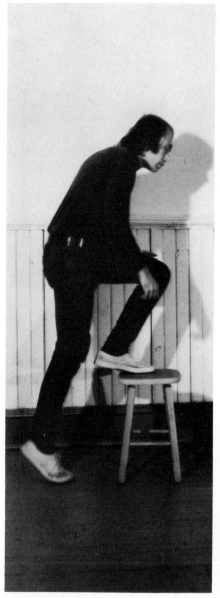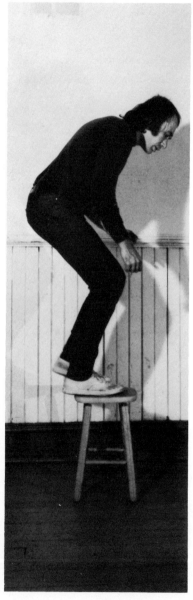

STEP PIECE

Project: An eighteen-inch stool is set up in my apartment and used as
a step. Each morning, during the designated months, I
step up and down the stool at the rate of thirty steps a
minute; each morning, the activity lasts as long as I
can perform it without stopping.

Progress Report: daily record of performance time:
First month (February, 1970):

Date		Duration
Feb.	1	3 min. 20 sec.
	2	3 min. 40 sec.
	3	3 min. 8 sec.
	4	3 min. 12 sec.
	5	3 min. 20 sec.
	6	3 min. 16 sec.
	7	6 min. 36 sec.
	8	8 min. 0 sec.
	9	8 min. 48 sec.
	10	3 min. 52 sec.
	11	9 min. 8 sec.
	12	9 min. 0 sec.
	13	10 min. 12 sec.
	14	10 min. 44 sec.
	15	11 min. 12 sec.
	16	11 min. 40 sec.
	17	13 min. 20 sec.
	18	13 min. 48 sec.
	19	14 min. 40 sec.
	20	14 min. 52 sec.
	21	15 min. 40 sec.
	22	17 min. 24 sec.
	23	18 min. 8 sec.
	24	19 min. 12 sec.
	25	20 min. 36 sec.
	26	21 min. 16 sec.
	27	21 min. 48 sec.
	28	23 min. 0 sec.

Second series of performances: April, 1970; 8 A.M. each day.

The daily training makes for improvement in duration. After the
layoffs, the effects of the training persist: improvement is more rapid
than in the first month of performance.

Announcements are sent to the public, who can see the activity per-
formed, in my apartment, any time during the performance-months.

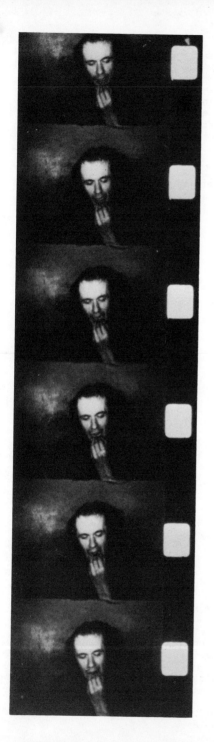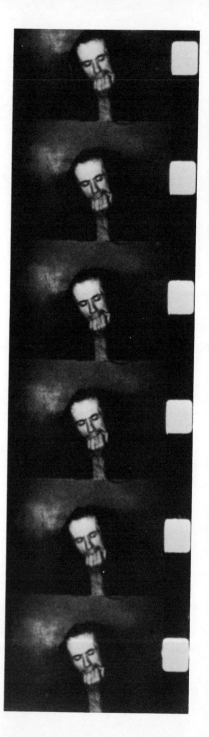

4

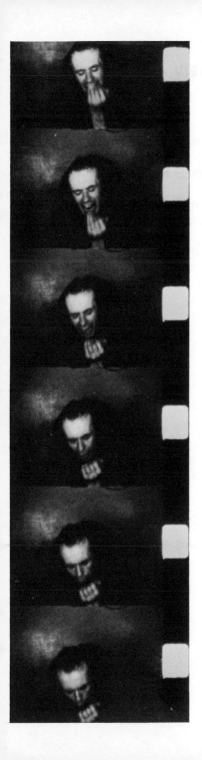

Pushing my hand into my mouth until I begin choking and am forced to release it.

Repeating the activity for the duration of the film.

Vito Acconci:
Hand in Mouth Piece.
1970. Film.

VITO ACCONCI

Learning Piece Statement, 1970

Playing, on tape, the first two phrases of a song (Leadbelly's "Black Betty"). Repeating the two phrases and singing along with them, until I have learned them and gotten the feel of the original performance.

Playing the next two phrases; repeating four phrases until I have learned them. Continuing by adding, each time, two more phrases until the entire song is learned.

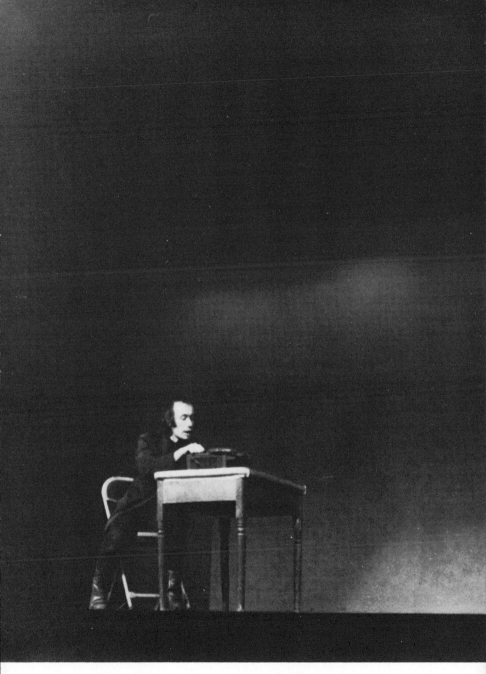

Learning Piece. 1970.

Map to not indicate: CANADA, JAMES BAY, ONTARIO, QUEBEC, ST. LAWRENCE RIVER, NEW BRUNSWICK, MANITOBA, AKIMISKI ISLAND, LAKE WINNIPE LAKE OF THE WOODS, LAKE NIPIGON, LAKE SUPERIOR, LAKE HURON, LAKE MICHIGAN, LAKE ONTARIO, LAKE ERIE, MAINE, NEW HAMPSHIRE, MASSACHUSETTS, VERMONT, CONNECTICUT, RHODE ISLAND, NEW YORK, NEW JERSEY, PENNSYLVANIA, DELAWARE, MARYLAND, WEST VIRGINIA, VIRGINIA, OHIO, MICHIGAN, WISCONSIN, MINNESOTA, EASTERN BORDERS OF NORTH DAKOTA, SOUTH DAKOTA, NEBRASKA, KANSAS, OKLAHOMA TEXAS, MISSOURI, ILLINOIS, INDIANA, TENNESSEE, ARKANSAS, LOUISIANA, MISSISSIPPI, ALABAMA, GEORGIA, NORTH CAROLINA, SOUTH CAROL-INA, FLORIDA, CUBA, BAHAMAS, ATLANTIC OCEAN, ANDROS ISLANDS, GULF OF MEXICO, STRAITS OF FLORIDA.

Terry Atkinson, Michael Baldwin: *Map*. 1967.

TERRY ATKINSON
Introduction*

This editorial is not intended to serve as a thorough compendium of the activity within the field of conceptual art, if it were, it would possess· lamentable shortcomings. Neither does it presume to represent conceptual artists in the U.S.A., nor many of those in Britain. There are three contributions from American artists in this issue; it is hoped that contributions from American artists will be maintained and increased and it is also an aim of this magazine to furnish a comprehensive report of conceptual art in the U.S.A. in one of the future issues this year. The essay below is specifically directed toward indicating the development of a number of artists in Britain who have worked in this field for the past two years. The formation of this magazine is part of that development and the work discussed in this essay is the work of the founders of this magazine. The essay will point out some differences in an indirect way, between American and British conceptual art, but it should not be seen to indicate a clear and definite boundary between them; there are British artists working in this field who show more affinity with American conceptual art than with what is, here, called British conceptual art. The editor-founders of this magazine have, for example, maintained close contact over the past year and a half with Sol LeWitt and Dan Graham. Their position is not at all seen by them to be one of isolation.

Suppose the following hypothesis is advanced: that this editorial, in itself an attempt to evince some outlines as to what "conceptual art" is, is held out as a "conceptual art" work. At first glance this seems to be a parallel case to many past situations within the determined limits of visual art, for example the first Cubist painting might be said to have attempted to evince some outlines as to what visual art is, whilst, obviously, being held out as a work of visual art. But the difference here is one of what shall be called "the form of the work." Initially what conceptual art seems to be doing is

* Reprinted from *Art-Language*, Vol. 1, No. 1 (1969).

questioning the condition that seems to rigidly govern the form of visual art—that visual art remains visual.

During the past two years, a number of artists have developed projects and theses, the earliest of which were initially housed pretty solidly within the established constructs of visual art. Many of these projects, etc., have evolved in such a manner that their relationship to visual art conventions has become increasingly tenuous. The later projects particularly are represented through objects, the visual form of which is governed by the form of the conventional signs of written language (in this case English). The content of the artist's idea is expressed through the semantic qualities of the written language. As such, many people would judge that this tendency is better described by the category name "art theory" or "art criticism"; there can be little doubt that works of "conceptual art" can be seen to include both the periphery of art criticism and of art theory, and this tendency may well be amplified. With regard to this particular point, criteria bearing upon the chronology of art theory may have to be more severely and stringently accounted for, particularly in terms of evolutionary analogies. For example the question is not simply: "Are works of art theory part of the kit of the conceptual artist, and as such can such a work, when advanced by a conceptual artist, come up for the count as a work of conceptual art?" But also: "Are past works of art theory now to be counted as works of conceptual art?" What has to be considered here is the intention of the conceptual artist. It is very doubtful whether an art theoretician could have advanced one of his works as a work of "conceptual art" in (say) 1964, as the first rudiments of at least an embryonic awareness of the notion of "conceptual art" were not evident until 1966. The intention of the "conceptual artist" has been separated off from that of the art theoretician because of their previously different relationships and standpoints toward art, that is, the nature of their involvement in it.

If the question is formed the other way round, that is, not as "Does art theory come up for the count as a possible sector of 'conceptual art'?" but as, "Does 'conceptual' art come up for the count as a possible sector of art theory?" then a rather vaguely defined category is being advanced as a possible member of a more' established one. Perhaps some quali-

fication can be made for such an assertion. The development of some work by certain artists both in Britain and the U.S.A. does not, if their intentions are to be taken into account, simply mean a matter of a transfer of function from that of artist to that of art theoretician, it has necessarily involved the intention of the artist to count various theoretical constructs as artworks. This has contingently meant, either (1) If they are to be "left alone" as separate, then redefining carefully the definitions of both art and art theory, in order to assign more clearly what kind of entity belongs to which category. If this is taken up it usually means that the definition of art is expanded, and art theoreticians then discuss the consequences and possibilities of the new definitions, the traditional format of the art theoretician discussing what the artist has implied, entailed, etc., by his "creative act." Or (2) To allow the peripheral area between the two categories some latitude of interpretation and consequently account the category "art theory" a category that the category "art" might expand to include. The category "maker of visual art" has been traditionally regarded as solely the domain of the visual-art object producer (i.e., the visual art artist). There has been a hierarchy of languages headed by the "direct readout from the object" language, which has served as the creative core, and then various support languages acting as explicative and elucidatory tools to the central creative core. The initial language has been what is called "visual," the support languages have taken on what shall be called here "conventional written sign" language-form. What is surprising is that although the central core has been seen to be an ever evolving language, no account up to the present seems to have taken up the possibility of this central core evolving to include and assimilate one or other or all of the support languages. It is through the nature of the evolution of the works of "conceptual art" that the implicated artists have been obliged to take account of this possibility. Hence these artists do not see the appropriateness of the label "art theoretician" necessarily eliminating the appropriateness of the label "artist." Inside the framework of "conceptual art" the making of art and the making of a certain kind of art theory are often the same procedure.

Within a context such as this the initial question can be

posed with a view to a more specific inquiry. The question: "Can this editorial, in itself an attempt to evince some outlines as to what 'conceptual art' is, come up for the count as a work of conceptual art?" Firstly, the established notions of what the presentation of art and the procedures of art-making entail have to be surveyed. The question "Can this editorial come up for the count as a work of art within a developed framework of the visual art convention?" can only be answered providing some thorough account is given of what is meant by "developed" here. At the present we do not, as a norm, expect to find works of visual art in magazines, we expect critical, historical, etc., comment upon them, photographic reproductions, etc. The structures of the identity of art-objects have consecutively been placed under stress by each new movement in art, and the succession of new movements has become more rapid this century. In view of this phenomenon perhaps the above question can be altered to: "Can this editorial come up for the count as a member of the extended class 'visual artwork'?" Here "extended" replaces "developed" and can, perhaps, be made to point out the problem as follows:

Suppose an artist exhibits an essay in an art exhibition (the way a print might be exhibited). The pages are simply laid out flat in reading order behind glass within a frame. The spectator is intended to read the essay "straight," like a notice might be read, but because the essay is mounted in an art ambience it is implied that the object (paper with print upon it) carries conventional visual art content. The spectator being puzzled at not really being able to grasp any direct visual art readout meaning starts to read it (as a notice might be read). It goes as follows:

"On why this is an essay"

The appearance of this essay is unimportant in any strong sense of visual-art appearance criteria. The prime requirement in regard to this essay's appearance is that it is reasonably legible. Any decisions apart from this have been taken with a view to what it should not look like as a point of emphasis over what it should look like. These secondary decisions are aimed at eliminating as many appearance similarities to established art-objects as possible.

Thus if the essay is to be evaluated in terms of the content expressed in the writing (WHICH IT IS), then in an obvious established sense many people would say that if it has a connection with art at all, that it fits better into the category "art criticism" or "art theory." Such a statement at least admits the observation that when an artist uses "(a piece of) writing" in this context then he is not using such an object in the way that art audiences are accustomed to it being used. But further it admits of a rather more bigoted view, that is this essay belongs more to art criticism or art theory because it is formed of writing and in this sense it looks more like art criticism or art theory than it looks like art; that is, that this object (a piece of writing) does not have sufficient appearance criteria to be identified as a member of the class "art-object"—it does not look like art. This observation has a strong assumption behind it that the making of a traditional art-object (i.e., one to be judged within the visual evaluative framework) is a necessary condition for the making of art. Suppose there are some areas (say) pertaining to art at present which are of such a nature that they need not, maybe cannot, any longer meet the requirements that have previously been required as a necessary mode of an object coming up for the count as a member of the class "artwork." This necessary mode is formulated as follows (say) the recognition of art in the object is through some aspect(s) of the visual qualities of the object as they are directly perceived.

The question of "recognition" is a crucial one here. There has been a constantly developing series of methods throughout the evolution of the art whereby the artist has attempted to construct various devices to insure that his intention to count the object as an art-object is recognized. This has not always been "given" within the object itself. The more recently established ones have not necessarily, and justifiably so, meant the obsolescence of the older methods. A brief account of this series may help to illuminate matters further.

1) To construct an object possessing all the morphological characteristics already established as necessary to an object in order that it can count as an artwork. This would of course assume that such established categories (e.g., painting,

sculpture) had already evolved through a period in which the relevant rules and axioms had initially to be developed.

2) To add new morphological characteristics to the older established ones within the framework of one object (e.g., as with the advent of the technique of collage), where certain of the morphological characteristics of the object could be recognized as the type criterion for assigning the objects of the category "painting" and other (newer) ones grafted onto them could not be so easily placed (e.g., in the introduction of Cubist collages and the collages made by Schwitters). This now historical controversy should be carefully distinguished, and such a distinction is relevant here, from that main controversy concerning Cubist paintings. Cubist paintings were paintings by definition, that is, they are constructed by adhering paint to a surface (two-dimensional by definition) and as such fulfilled the requirements of entry to the category "painting." The controversy concerning Cubist paintings was not primarily about whether or not they were (physically) paintings, but rather whether or not their form (in paint) was viable, Cubist collages were questioned on both levels.

3) To place an object in a context where the attention of any spectator will be conditioned toward the expectancy of recognizing art-objects. For example placing what up to then had been an object of alien visual characteristics to those expected within the framework of an art ambience, or by virtue of the artist declaring the object to be an art-object whether or not it was within an art ambience. Using these techniques what appeared to be entirely new morphologies were held out to qualify for the status of members of the class "art-object." For example Duchamp's "Ready-mades" and Rauschenberg's *Portrait of Iris Clert*.[1] There is some considerable overlap here with the type of object mentioned in No. (2), but here the prime question seems to emphasize even more whether or not they count as art-objects and less and less whether or not they are good or bad (art-objects). David Bainbridge's *Crane*,[2] which shifted status according to his "sliding scale" intentions as to where it was placed at different times, threw up an apparently even thicker blanket of questions regarding the morphology of art-objects. In contrast to

[1] 1961.—Ed.
[2] 1966.—Ed.

Duchamp's "Ready-mades," which took on art-object status according to Duchamp's act of (say) purchase (e.g., *Bottle Rack*[3]) entailing an asymmetrical transfer or rather superimposition of the identity "art-object" onto that of "bottle rack," Bainbridge's *Crane* sometimes is a member of the class "art-object and crane" and sometimes simply is only a member of the class "crane." Its qualification as a member of the class "art-object" is not conceived as being reliant upon the object's morphological characteristics but on Bainbridge's and Atkinson's list of intentions acknowledging two kinds of ambience, art and not-an-art ambience. Here the identity (art-object or crane) is symmetrical. Some other aspects concerning *Crane* will be discussed further on.

4) The concept of using "declaration" as a technique for making art was used by Terry Atkinson and Michael Baldwin for purposes of the "Air-Conditioning Show" and "Air Show," which were formulated in 1967. For example the basic tenet of the "Air Show" was a series of assertions concerning a theoretical usage of a column of air comprising a base of one square mile and of unspecified distance in the vertical dimension. No particular square mile of the earth's surface was specified. The concept did not entail any such particularized location. A quote from some of the preliminary notes from the "Air Show" will perhaps serve to elucidate the concept further:

"A persistent objection that there has so far been no indication that the 'Air Shows' etc., are any more than fictional entities (insofar as it doesn't seem to matter if that is what they are), whereas paintings, sculptures, etc., are real things —concrete entities, offering actual concrete experiences, can be answered only by the evincing of possible instrumental 'tests,' etc. (observations): when an assertion is made to the effect that a sculpture (say) is made of 'real' gold, etc., there is an implication that it is not made of an imitation, or that it is not defective in some way. Something like that can be said of the 'Air Show'—but not about the situation (i.e., the described state of affairs)—it is said of the concept: the question as to whether or not one can say that something is 'real' here, is not one that comes up naturally, the circumstances

[3] 1914.—Ed.

15

in which such a question might arise might be those in which one is looking for concept defects (being fictional).

"The objector is just asserting that these 'things' don't occur in a series of persual (perceptual) situations."

No. (4) differs from Nos. (1), (2), and (3) in the following way. The first three methods use a concrete existential object, the latter simply a theoretical one. This factor of "use" is important here. The existential object upon which the "content" of No. (4) is formulated (i.e., paper with print upon it) is not the art-object, the art-object is not an object that can be directly perceived, the "object" component is merely specified. Once having established writing as a method of specifying points in an inquiry of this kind, there seems no reason to assume that inquiries pertaining to the art area should necessarily have to use theoretical objects simply because art in the past has required the presence of a concrete object before art can be thought of as "taking place"; having gained the use of such a wide-ranging instrument as "straight" writing, then objects, concrete and theoretical, are only two types of entity that can count, a whole range of other types of entities become candidates for art usage. Some of the British artists involved in this area have constructed a number of hypotheses using entities that might be regarded as alien to art. Most of these inquiries do not exhibit the framework of the established art-to-object relationship and (if you like) they are not categorically asserted as members of the class "art-object," nor for that matter is there a categorical assertion that they are art ("work"); but such a lack of absolute assertion does not prohibit them from being tentatively asserted as having some important interpellations for the art area.

This concept of presenting an essay in an art gallery, the essay being concerned with itself in relation to it being in an art gallery, helps fix its meaning. When it is used as it is in this editorial, then the art gallery component has to be specified. The art gallery component in the first essay is a concrete entity, the art gallery component in the second case (here) is a theoretical component, the concrete component is the words "in an art gallery." Lists (1), (2), (3), and (4) above might be followed by (5), the essay in the gallery, and (6) the

essay possessing the paragraph specifying the theoretical art gallery; it is more likely that the nuances of (5) and (6) could be included in an expanded version of (4).

The British "conceptual artists" are still attempting to go into this notion of the meta-strata of art-language. Duchamp wrote early in the century that he "wanted to put painting back into the service of the mind." There are two things to be especially taken into account here, "painting" and "the mind." Leaving aside here ontological questions concerning "the mind," what the British artists have, rightly or wrongly, analyzed out and constructed might be summarized in words something like: "There is no question of putting painting, sculpture, *et al.*, back in the service of the mind (because as painting and scultpure it has only served the mind within the limits of the language of painting and sculpture and the mind cannot do anything about the limits of painting and sculpture after a certain physical point, simply because those are the limits of painting and sculpture). Painting and sculpture have physical limits and the limit of what can be said in them is finally decided by precisely those physical limits." Painting and sculpture, *et al.*, have never been out of the service of the mind, but they can only serve the mind to the limits of what they are. The British conceptual artists found at a certain point that the nature of their involvements exceeded the language limits of the concrete object, soon after they found the same thing with regard to theoretical objects, both put precise limits on what kind of concepts can be used. There has never been any question of these latter projects coming for the count as members of the class "painting" or the class "sculpture," or the class "art-object," which envelops the classes "painting" and "sculpture." There is some question of these latter projects coming up for the count as members of the class "artwork."

A little has to be said of Duchamp's work here for other reasons besides those already stated. It has been maintained by some commentators upon early American and British conceptual work that Duchamp's influence is all-pervasive and his aesthetics are totally absorbed and accepted by the younger generation of artists today. If this is meant to mean that Duchamp is treated uncritically as a kind of "gospel"

then it is certain that at least the British group will disagree with this assessment. Two early projects by the British artists can serve as examples here to point out the extent of the analysis that these artists engaged in looking at Duchamp's ideas; some more remarks on Bainbridge's *Crane* and Terry Atkinson's and Michael Baldwin's *Declaration Series.*

Crane is a comparatively early work (1966), and what has been written already will be of some importance here. Bainbridge and Atkinson had discussed the theoretical possibilities of what they called a "Made-made" whilst Bainbridge had been building the *Crane,* in the summer of 1966, in response to a commission from Camden Borough Council, North London, that he should design a functional crane to serve as a recreational "plaything" in one of the council's play parks. When the *Crane* was finally implemented in a park in November, 1966, Bainbridge and Atkinson decided it was a fortuitous situation to apply the "Made-made" concepts, and perhaps to develop them further. The *Crane* can in some ways be seen to entail an opposite "direction" to that entailed in (say) the *Bottle Rack;* the "Bottle Rack" manufactured in a nonart mass-production area and admitted into an art area by virtue of Duchamp's act of placement (within the art of ambience): the "Crane" manufactured in a high art environment (St. Martins School of Art Sculpture Faculty) and dispatched "out-into" the not-art environment. But the *Bottle Rack* and the *Crane* shared certain characteristics, which was that the intention of the artists has to be precisely specified by the artist through schema external to the object itself. The Bainbridge-Atkinson system had to have an initial implied art-object status for it to be followed by a declaration that the object was no longer an art-object. This implied "I am building an art-object in order to declare it not an art-object at some future instant" is somewhat moronic standing alone, but it does offer purchase for the construction of a theoretical system that has a logic of symmetrical identity. There seems no reason why the *Crane* cannot theoretically be placed back in the Tate Gallery for a time. (Such a system might be applied to Duchamp's *Bottle Rack* except Duchamp seems to have left no evidence of any intention to allow the *Bottle Rack* such a transitive identity and one assumes that Duchamp's art will be measured according to the intentions

of Duchamp—it may be a rash assumption in view of the fact that the job of many critics today seems to be that of deciding what the artist's intentions are with regard to the objects he makes and further many artists allow, encourage, and rely upon the critic to do this.) This leads to another point. Both the *Bottle Rack* and the *Crane* are small and mobile enough to allow this placement-identity system to be feasibly attached to them; the *Crane* with its shifting context had, as an inevitable by-product, brought up the question of an object's temporal characteristics (i.e., theoretically its membership of the class "crane and not art-object" ended when its membership of the class "crane and art-object" began— a series of phase sortals built up as the *Crane* was theoretically converted and reconverted again and again).

The Atkinson-Baldwin *Declaration Series* (March–April, 1967) tendered the next series of assertions in the declaration-device projects. The theoretically material mode of these assertions related in many ways to *Crane.* Many of the details of the assertions were never more than conversation and this is probably the first attempt to record them systematically. As a starter a rather trite inventory will suffice. If a bottle rack could be asserted as a member of the class "art-object," and a crane can be asserted to be at one time a member of the class "crane" and at another time a member of the class "crane and art-object" and then can be asserted to lose its "art-object" status (and so on), all these changes being dependent on changes of ambience perhaps a further development can be constructed through applying such an assertion of declaration to ambiences rather than objects. Hence if a bottle rack can be asserted as a member of the class "art-object" then why not the department store that the bottle rack was displayed in, and if the department store then why not the town in which the department store is situated, and if the town then why not the country . . . and so on up to universe scale (and further if you like!). In order to set up a framework in which more detailed and specific assertions might be made, Atkinson and Baldwin decided to use Oxfordshire in England as a theoretical basis. (Here theoretical use is not discernible from concrete use as one would not move Oxfordshire or in some way spatially change it internally as part of the schema.) Such an entity guar-

anteed sufficient contrast with the *Bottle Rack* and the *Crane.* Short of digging Oxfordshire out (and one would have to decide, either arbitrarily or otherwise, how deep it is) it is a comparatively fixed spatial entity. This eliminates any question of moving it into what is called an art ambience as a first obvious point of note. If then Oxfordshire is declared to be an art ambience, how are the objects within Oxfordshire to count? Do then Magdalen College, Christchurch Meadow, a Volkswagen in Banbury High Street, etc., etc., count as art-objects? There seems no need to get hung up on answering such questions, the framework was set up in the main to supply a "ready-made" art ambience in contrast to a "ready-made" art-object, such questions as the above ones merely serve to illustrate some possible implications. The framework is to be held out as one in which decisions concerning the "whole" are not now decisions primarily concerned with the spatial characteristics of the situation but more explicitly with the temporal dimensions (i.e., the "beginning" and the "ending" [if there was to be an ending] of Oxfordshire being "converted" into an art ambience). The question is not, "What or where becomes an art ambience?" but more, "When, what, or where becomes an art ambience?" The *Declaration Series* was closed up by Atkinson and Baldwin through the development of a framework investigating the notion of declaring a temporal entity to be an art entity—*The Monday Show.* Most of the conversation and writing concerning this idea soon reached a desultory level—it was unnecessary to attempt to provide an adequate analogy to a spatial entity, because it was quickly and clearly evident that there wasn't one. What has become clear to the artists since is that this work was a necessary form of development in pointing out the possibilities of a theoretical analysis as a method for (possibly) making art.

Something might now be said noting the relationship of the psychology of perception with regard to "conceptual art." It is today widely agreed that the psychology of perception is of some importance in the study of visual art. The practice of this study by art theoreticians, for example Ehrenzweig, Arnheim, etc., has at least clarified some questions within the context of visual "visual art," which have enabled the conceptual artists to say these (such and such) projects have

not such and such characteristics, in this way they have influenced what the formulative hypotheses of some of conceptual art is not about. Such concepts as whether art consecrates our ordinary modes of seeing and whether or not we are able, in the presence of art, to suspend our ordinary habits of seeing are strongly linked with inquiries into Gestalt hypotheses and other theories of perception; the limits of visual art are often underlined in inquiries into how we see. The British group have noted particularly and with deep interest the various Gestalt hypotheses that Robert Morris (for example) had developed in the notes on his sculpture-objects. These notes seem to have been developed as a support and an elucidation for Morris' sculpture. The type of analysis that the British group have spent some considerable time upon is that concerning the linguistic usage both of plastic art itself and of its support languages. These theses have tended to use the language form of the support languages, namely word-language, and not for any arbitrary reason, but for the reason that this form seems to offer the most penetrating and flexible tool with regard to some prime problems in art today. Merleau-Ponty is one of the more recent contributors to a long line of philosophers who have, in various ways, stressed the role of visual art as a corrective to the abstractness and generality of conceptual thought—but what is visual art correcting conceptual thought out of—into? In the final analysis such corrective tendencies may simply turn out to be no more than a "what we have we hold" conservatism without any acknowledgment as to how art can develop. Richard Wollheim has written, ". . . but it is quite another matter, and one I suggest, beyond the bounds of sense, even to entertain the idea that a form of art could maintain itself outside a society of language-users." I would suggest it is not beyond the bounds of sense to maintain that an art form can evolve by taking as a point of initial inquiry the language-use of the art society.

TERRY ATKINSON, DAVID BAINBRIDGE, MICHAEL BALDWIN, HAROLD HURRELL
(Editors of *Art-Language*)

Lecher System*

This apparatus consists of two parallel wires along which a high-frequency radio wave is guided. Reflection occurs at the far end and standing waves are produced. At voltage and current antinodes, that is where the voltage and the current differences are at a maximum, detection of this may be made by the application of suitable means. These voltage antinodes are ½ wavelength apart and current antinodes are similarly spaced but shifted ¼ wavelength along the wires. That is that if a 1 meter wavelength were generated there would occur antinodes every quarter meter, being alternately of the kind voltage, current, voltage, current, etc.

DETECTION

At certain points, which are voltage antinodes, the voltage difference between the two wires will be at a maximum. At other points are current antinodes which are detected by connecting a 1.5 v. torch bulb across the two wires. The torch bulb holder is connected to two stiff wires and inserted in a test tube which serves as a handle. With the hand held well away from the Lecher wires, the torch bulb is slid along on its connecting wires, and the points where the bulb lights most brilliantly are noted.[1]

COMMENT

The complete arrangement possesses a "sculptural morphology" and an "electromagnetic morphology." "Critical perceptual performances" regarding the former supply knowledge of quantitative aspects of the latter, and, from this, a further deduction "back" extends knowledge regard-

* Reprinted from *Studio International,* Vol. 180, No. 924 (July/August, 1970).

[1] C. H. Bailey, *The Electromagnetic Spectrum and Sound* (Pergamon Press, 1967).

ing the former. The whole affair is thus nonampliative in a theoretical sense, being a demonstrative business much rather than a "revelatory" one.

The scale of this arrangement is such that it may be regarded as a "natural sculpture." Assuming as requisite to "natural sculpture" to be morphological characteristics that exist within the resolving power of the human visual perceptual capacity. This implies objects within a particular range of dimensions; arbitrary though this might seem there is a strong cultural precedent; we would, I think, have less difficulty in regarding a 1 meter cube as sculpture than a 1 centimeter, or even 10 centimeter cube as sculpture; small variations of form would be lost on us at this scale. Similarly a 10 meter cube, although if this was all it were, could hardly be anything other than sculpture, employing the cultural precedent it would not be regarded as "natural sculpture" anymore than the Pyramids or Blackpool Tower are normally seen as "natural sculpture." Likewise small variations of form would be lost when viewing the totality.

Thus the Lecher system here employed falls within these confines of natural sculpture almost completely. The wavelength employed is of the order of 1.5 meters (about 5 ft. 7½ in.—highly anthropometric) and with the Lecher arrangement this can be obtained within *appreciable dimensions* "whereas its corresponding coil and condenser arrangement might be microscopically small."[2]

Spectator Y: This could perhaps be regarded as sculpture; my own analytical procedures may be inappropriate here: they rely a good deal on Panofsky's notions of tri-stratified subject matter.
Spectator X: The thing is too discursive and convoluted. This is partly due to formal/functional equivocity.
Y: It is also iconologically opaque. That is not to say that one can't account for it, iconologically significant accounts and "ordinary" ones aren't necessarily mutually exclusive.
X: The bulb, for instance, is "climactic." The electromagnetic aspect gets in the way more. There is a lack of specificity.
Alien: I am not clear what the criteria of individuation are for

[2] G. Southworth, *Principles and Applications of Waveguide Transmission* (New York: Van Nostrand, 1950).

sculpture. I can observe the waves directly—you can't. If you have to use instruments, etc.—and various logical operations, do you thereby obscure the possibilities of singling the thing out essentially? Your singling-out procedures appear to be macroscopic. You have no adequate "ordinary vocabulary" for dealing with such things as "lines of force."

X: Robert Morris has written that the size-range of useless three-dimensional things is a continuum between the ornament and the monument. Sculpture has generally been thought of as those objects not at the polarities but falling between them.

Alien: The waves are highly linear much like the dotted lines in the diagram in the catalogue indicate; would these be called three-dimensional things?

X: I doubt it.

Alien: The situation is doubly fraughtuous. I mean irrespective of whether or not you count the waves as three-dimensional, the thing runs against the simplistic tenets of "Minimal Art."

Y: I am used to thinking of Giacometti's and Moore's as sculptures. The iconographical vacuity of the piece may disappear at a metatheoretical level. At the moment, I still see just a bulb, bits of wire, etc. The intentionality of the piece is far from clear.

Alien: Is the prospect of iconological interpretation of the piece conceptually tied to the notion of intention?

Y: Morris sometimes proffers even "guides," "rules" for interpretation. These are analogous to semantic axioms.

Alien: These might generate a regress. Also, some iconologically propelled spectator might fasten something symbolic to "the wave form."

Y: Certainly.

Alien: What then are artists for? Do they provide interpretational paradigms—even axioms? Motivational talk makes the situation worse.

Y: There is, according to Bainbridge, a "natural sculpture" aspect to the object. But seeing this is not his sole prerogative.

X: The construction of a hierarchy of insight authenticity is the spectator's prerogative.

Alien: Interpretations are not always associated with closed (e.g., semantic) systems. Any link between intention and art is conceptual not logical.

X: It's only recently that sculptors, etc., have talked so much.

Alien: Morris talks about sculptural paradigms. From conversations with my friend (who was associated with the M1 pieces), it seems that one can know that a thing is art without having criteria of "artness" which cater for odd or controversial cases. This may well generate—on the other hand—be generated by—identity problems. What about electromagnetic morphology?

X: There is Takis—and perhaps other "kinetic" artists.

Alien: From what I remember of Paris in the 50's, there was in Takis a "direct" (for you) demonstration of the effects of electromagnetic activity. One can equate Bainbridge's notion of "natural sculpture" with Morris' criterion of size; however he appears to have no reservations as to strongly inflected internal relations. One is very soon not only discussing conditions of art-objecthood but also conditions of art-spectatorhood.

It does seem though that you Earthlings can easily visualize an electromagnetic morphology though only by analogy with, for example, a sculptural morphology; the question seems to be what status you are prepared to allow such procedures. In the case of this piece the sculptural morphology is what generates the electromagnetic morphology. An issue may perhaps be made between formal/theoretical and instantial priorities.

Loop

An induction-loop would be installed in the gallery and receivers freely available. The effective field of this loop would be curtailed well short of the extremities of the gallery. Thus a visitor equipped with receiver, wandering through, could expect to find very many positions where no signal is received, and many where one is received. This signal would be without variety, the receiver being capable of only two states, quiescent and active, depending on the visitors location within or out of the loop.

A visitor, suitably equipped with receiver and locomotor inclination, would find that in moving into the gallery, after several steps with nothing issuing from the instrument, a point is reached when a signal is received. He would find that further progress in any direction (other than reverse) brought about no further change in the receiver's state and a signal of constant pitch and intensity is heard. After several further steps this signal would abruptly cease. After some minutes the visitor might be prepared to assign a 'form' to an area of the gallery and a patient and methodical visitor might endeavour to offer some 'dimensions' of this area.

The loop itself, consisting of a fine wire, would either be fixed to the ceiling or located under a carpet, provided it went wall-to-wall, either way one would try to conceal it.

David Bainbridge, Harold Hurrell: *Loop.* 1967.

DAVID BAINBRIDGE

Notes on M1*

Consider an alien being from another galaxy invited by a
gallery entrepreneur to "show some work." His culture
knows no art to speak of and he therefore seeks the brocards
operative for earth-artists. Thus he visits the National Gal-
lery, Louvre, Prado, Guggenheim, etc., in an attempt to clarify
what is expected of him (having previously found theses and
letters of various artists of no avail). His observations perplex
him and are of little use for he has encountered innumerable
morphological[1] kinds from which he is unable to adduce any
parameter or isogeny of motivation. Upon reflection, however,
it occurs to him that a fundamental condition operative in all
the galleries he visited was the *laissez aller* manner in which
the visitors were allowed to make their encounters of the
artworks. Hence he decides he is required to manufacture a
piece capable of generating this transient interest, and al-
though it seems virtually any object so located in such an
establishment would achieve this end, he is conscious that
perhaps something more is required (a not unreasonable
assumption on his part if only in the sense that his presence
on earth and having established some communication attests
to a high order of technical sophistication).

Thus he might formulate the following posit.—"It would
appear that earth folk obtain some measure of gratification
from the manumission of their locomotor activity, yet aimless
meandering they seem to anathematize. So if I construct a
system allowing unfettered locomotion and having some
meaningful aspect as a product of these locomotions, I would
violate neither condition. By using capacity switches to
initiate some form of display I would have just such a system
and would also gain some purchase on morphological contin-
gency in that the sensors would be sculpture, their form, in
part at least, being determined by the switch-gear."

Before considering the details of this device there are per-

* Reprinted from *Art-Language*, Vol. 1, No. 1 (1969).
[1] See Terry Atkinson, "Notes on M1."

haps two points to raise. One is the supposition that he would see the thing in terms of what is required or expected of him, the other is the manner in which he obtained his posit. These are obviously not unconnected since if one were not seeking requirements, one would hardly be obliged to adopt any particularly systematic method. On the first point, it is unlikely any earth-artist would see it in this manner, the suggestion that his activities are, or might be, so inclined as to meet other people's expectations he would doubtless cavil. However, an alien might well see as a requirement the necessity for his work to exist within the range of tunable human perception. That the earth-artist has no choice other than to operate in this range makes it unnecessary for him to formulate such a notion since it is inconceivable that he might produce anything subject to a different thermodynamics from that governing him. Yet for an alien, it is possible to apprehend this as a concept, and in doing so there could occur at least one new aspect.

The second point concerns the alien's proclivity for percept rather than inference. This, what might be called ultra-empirical method, comes about simply because that of all the powers one might conveniently assign to a fictitious alien, it serves to contribute little to the discourse to make them unreasonably magical[2] and I have consequently simply subsumed a technical orientation.

The alien's notion that an observer's locomotion is an integrant "issue" is similar to his idea of a sensory requisite only so far as he is starting with nothing so to speak. These issues are quite dissimilar if one considers that, whereas art may occur (albeit probably not as sculpture) despite the vitiation of the first point, and locomotor constraint apply. Not so were he to disregard the second point and fail to meet the sensory requisite. He would not proffer the first point as a statement seeking to uniquely define sculpture (though he might reasonably insist on its inclusion in one which did), anymore than he would accept its validity being certified by its acceptance by sculptors. Moore might or might not, Caro might or might not, two telephone calls would probably supply the answer, but what of Brancusi, Michaelangelo, Rodin, Smith, *et al.?* Rather it serves merely as a propaedeutic framework reminding him of his purpose.

[2] See Marvin Minsky, "Minds, Matter and Models."

He has said that he sees as necessary, "some meaningful aspect as a product of locomotion." The implication here is that whatever form this meaningful aspect might take, it must be as an attribute of the system and not ordained. Accrediting qualities by ordination would be nonsensical in this case for, apart from having subsumed a technical orientation, we know nothing about this alien. We are in much the same position we would be on encountering work by Gabor's Mozartian Man.[3]

HARDWARE

The capacity switch-gear incorporates a silicon-controlled switch arranged to permit a flow of current when the capacity of a sensing plate is increased by the proximity of a person. Varying proximities are obtained by increasing or decreasing the size of the sensing plate, generally the greater the area of this plate, the less close a person need be for switching to occur. Fine tuning is achieved by means of a trimmer. When such a device is connected to some external circuit supplying a "display," this will be switched on/off according to the human trafficking at, or in, the sensing threshold. Thus the behavior of this display is an attribute of the visitor-sensor (sculpture) system.

Sculpture: Technically, the sensing plate cannot be less than about 24 sq. in. and the proximity required for such an area would be about 2". Now the prospect of having a visitor approach to within 2" of a metal plate 6" x 6" is quite inconsistent with the alien's observations. He had observed that a majority of sculpture was a good deal larger than this, and visiting traffic occurred at distances considerably greater than 2". Thus he either endeavors to find a mean between the sculptural Brobdingnagian and the sculptural minuscule and engineer the proximity via the fine tune (trimmer). Or, alternatively, he may begin with a positive notion of the kind of proximity he thinks consistent with his observations and calculate the requisite size from the visual angle he thinks it reasonable it could subtend. A somewhat lengthy, dubious, and in its own way, no less arbitrary process.

Display: The display consists of a turning/not-turning disc, the transform occurring on impingement at the threshold

[3] See Dennis Gabor, *Inventing the Future.*

causing it either to start or stop, since he is not interested in gestural anthropomorphics it matters not which. A capacity switch would not normally be employed proportionately as its reliability would be difficult to guarantee. A light display might equally be used.

Software: Thus were this system to be used, on entering the gallery you would see two objects. One a metal plate 27″ x 27″, suitably supported in the vertical plane, its center about three feet from the floor and the second object some distance away consisting of a small box, a disc on the frontal face, supported about the same height. On approaching the plate, at about three feet, you might notice the disc begin to turn (or stop turning) and continue as you circumnavigate the plate and move off (to investigate the display nidus?), on crossing the threshold again the display reverts to its former state and, assuming no one else is within proximity, remains at this condition.

So far this might be the alien's idea of a solution, it seems, however, not quite enough since there occurs a feature of an endiectic of this kind which is problematic and apparently a little unusual. The problem lies in the unimportance of the visual form of these objects and how some aspect of the system might positively attest to this fact, a point not so unusual provided the empirical origins are not forgotten.

Thus the hardware he might now install in the gallery might consist of two such plates and two discs upon the single nidus. These additions allow a choice of couplings (6) but in particular one with the requisite aspect through which visual criteria are rendered perfunctory. This is a cross-coupling employing an AND operation switch having display contingent upon the simultaneous encounter of both plates (sculptures), and the implication is strong that these sculptures have no per se meaningful attributes (within the system). Another (dubious) factor is the axiomatic banality, in the percept sense, of in excess of 730 sq. ins. of unrelentingly homogenous "galvanizing." Consider also that, although all physical attributes of this complex are so to contribute to some function, in having a variety of 6 couplings, at any one time 5 are redundant and cannot be accounted for in these terms at that time. Thus what visual evidence there is of these couplings

and that they appear to contribute nothing means either, they are dismissed as indulging whimsy and are superfluous, or as further evidence that no purpose is served by assigning visual predicates, or rather, a perfunctory ratiocinate results since no cognizance of that aspect on which the labor occurred is taken.

That the alien has prodromally articulated a desiderate to "operate within the tunable range of perception" yet seems to intimate that the visual capacity need not, indeed should not, be employed does not conflict provided a broad interpretation of tunable is allowed. In the broader sense it may be taken to mean the treatment of the visual capacity as a gross function, capable only of such statements as "something there and something behind and to the left of it." Or as a course-tuner dealing with spatial resolutions. The acumination of properties, detail, pageant, and complex, would (in this sense) require fine-tuning. The posit suggests in this broader interpretation that the solution should be sensile, whereas the alien's remarks on the unimportance of the visual form refer to the requisite abnegation of fine-tuning vis-à-vis his system.

So, in his one-man show, this alien from another galaxy presents some work, which perhaps, contrary to implication, is different in an important way from preceding art shows. If we regard the implication of these a posteriori methods as an attempt to establish a situation wholly concordant with previous exhibitions of sculpture, he would appear to have failed. In antecedent exhibitions, the number of people in the gallery (opening night apart), had little effect on an individual making whatever "readings" he might of the exhibits. In the alien's case, however, not only has he endeavored to reduce meaningful "readings" to one, but the potential for making that reading is threatened the moment a second visitor enters the gallery, and thwarted should this second visitor maintain proximity. That the whole affair is rendered meaningless by a plurality of visitors is a departure from precedent. Such originality may be forgiven only if we accept the possibility that such were the conditions he observed, that is, he never observed more than one person at a time in any gallery he visited. However, having subsumed a technical orientation, such negligent induction, it might be objected, is difficult to explain.

JOHN BALDESSARI

John Baldessari
Cremation Piece, June 1969.

"One of several proposals to rid my life of accumulated art. With this project I will have all of my accumulated paintings cremated by a mortuary. The container of ashes will be interred inside a wall of the Jewish Museum. For the length of the show, there will be a commemorative plaque on the wall behind which the ashes are located. It is a reductive, recycling piece. I consider all these paintings a body of work in the real sense of the word. Will I save my life by losing it? Will a Phoenix arise from the ashes? Will the paintings having become dust become art materials again? I don't know, but I feel better."

A WORK WITH ONLY ONE PROPERTY.

A Work with Only One Property. 1966–67. Acrylic on canvas.

Inert Gas Series. 1969. Helium; 2 cu. ft. ·
to indefinite expansion. Mojave Desert.

ROBERT BARRY, October 12, 1969*

Can you tell me how you developed away from your earlier painting and how you arrived at your present invisible work?

I found that paintings—my paintings were different in the way they were hung or exposed to light. I wanted to incorporate that idea in my art. Also my paintings related always to the edge of the canvas as though I wanted to blend them into the wall. I was not satisfied anymore with staying on the wall. I wanted to get involved with the entire room, the entire space. Also I wanted to get away from the concern with color. The idea is to work with the space in which the art occurs. I did not want to control space variables, I wanted to incorporate them in my art. And I did not want to impose myself on my material or on the space. I was trying to get away from some sort of style.

Would you agree that art is the more extreme the further it gets away from style?

Yes, I agree. I cannot really give you my definition.

Somebody said that style was the manipulation of the space between our emotional involvement with reality and reality itself. The further we get away from reality the more dehumanized art becomes, as Ortega y Gasset said. Whereas I try not to manipulate reality, not to impose my preconceived grid or preconceived system onto reality, I—to use Heidegger's phrase, let things be. What will happen, will happen. Let things be themselves.

Would you care to tell me your thoughts about Anti-Art?

I think the most beautiful thing about modern art is that it has built into its own potential the capacity for destroying itself. Nothing keeps renewing itself the way art does. The fundamental beliefs in art are constantly threatened and as a result it is constantly changing; and so art and Anti-Art are really the same thing. There isn't any real difference between them I guess it is the great fantasy of modern artists to be able to make their art—without having to make art.

* Conversation with the editor.

Does this fantasy account for the problem that the object poses to contemporary artists? Or has this object controversy to do with cultural and psychological despair?

Certainly it is psychological, but we are not really getting away from the object; we are producing a different kind of object. I did not get away from it. I have not *produced* objects; maybe I found objects. We are not really destroying the object, but just expanding the definition, that's all. Like art, that keeps on being expanded, that seems to include more and more things.

For example, would you call the dust that artists use in certain works, an "object"?

Why, of course, it is a very materialistic object. These guys are very interested in material and material function. They are interested in the way the material works, how it reacts in a very fundamental way to gravity, and what they produce are objects, tangible things that can be seen, touched, and walked around.

I think what has been deobjectified is the coherence of the object. Doesn't the concern for the material substitute for the coherence of the object?

Well, the material always seems to cohere somehow whether the artist wants it or not. No matter how the dust is spread around, it all fits together into some kind of grand design.—We are looking at objects from another point of view, so that it seems that art is changing, but I personally do not see a real difference between the new art and the "traditional" art of the object. This may be due to changed emphasis of certain aspects of the new objects that we did not emphasize in the object of the past, like changeability and temporality. Objects may change right before your eyes.

Let us go back to your pieces made of extended wire.

Yes. The wires were so thin and were in certain pieces stretched so high above the ground that it was virtually impossible to see them—or to photograph them. And from that I went to things that could be neither seen nor perceived in any way. My father, who is an electrical engineer and always worked with carrier waves and radio transmitters, ever since I was a kid—helped me out and that was the thing I knew about. I guess it was the first invisible art. It could not be perceived directly. And in the "January 1968 Show"

(Seth Siegelaub) I included several carrier wave pieces. One was called *88mc Carrier Wave (FM)* and another—*1600 kc Carrier Wave AM.* Since you cannot photograph a carrier wave, we had to photograph the place where the carrier wave existed. The carrier waves have several very beautiful qualities. For example, they travel into space with the speed of light. They can be enclosed in a room. The nature of carrier waves in a room—especially the FM—is affected by people. The body itself, as you know, is an electrical device. Like a radio or an electric shaver it affects carrier waves. The carrier waves are part of the electromagnetic spectrum of which light waves are also a part. A carrier wave is a form of energy. Light waves are made of the same material as carrier waves, only they are of a different length. A person is also a source of some kind of a carrier wave. Let me call that telepathy. The form of a piece is affected because of the nature of the material that it is made of. The form is changed by the people near it although the people may not be aware of the fact that they are affecting the actual form of the piece, because they cannot feel it.

Can it be measured?

For any transmitter a receiver can be built that picks up what the transmitter sends out. It is interesting that these carrier waves, which go over the radio spectrum, can be picked up on the radio. When I left the carrier waves clean and turned on the radio, the stations went silent where the carrier waves were.

Another piece was the *New York to Luxemburg CB Carrier Wave.* On January 5 I sent the CB carrier wave on a ham radio to Luxemburg. Seth wanted the dimensions of the piece. I gave him the megacycles and watts.

And then there was this piece in Seth's show: *40 KHz ultrasonic soundwave installation* (January 4, 1969). We call it sound wave, I do not know why, because we cannot hear it. Ultrasonic sound waves have different qualities from ordinary sound waves. They can be directed like a beam and they bounce back from a wall. Actually you can make invisible patterns and designs with them. They can be diagramed and measured. I will do a piece for Jack Burnham for his show. I believe in the Jewish Museum. I have to go to the place and work with the walls right then and there.

My piece *0.5 Microcurie Radiation Installation* (January 5, 1969), *Barium 133* (1969) consists of small radioactive isotopes—buried in Central Park—that emit radiation. Once again we photographed the place. Radiation waves are way up in the upper echelon of the electromagnetic wave spectrum; they are much shorter than light waves. Light will stop at the wall. Radiation will go right through it. A radioactive isotope is an artificial material. It has—what they call Zero time—beautiful expression! That is the time when it is created. On the label of the small plastic vial in which it is contained, its "Zero time" is printed. From that moment on it starts losing its energy. Now the "half-life" in this particular case was ten years, which means that every ten years its energy is decreased by half; but it goes on to infinity, it never goes to nothing. Some isotopes have a half-life of a millionth of a second, some have a half-life of four billion years and some of fifteen minutes: i.e., every fifteen seconds the energy is halved. *But it never goes out of existence.* They are perfectly harmless. A world of things can be done with this incredible material. And it is just letting them do what they are supposed to do. You cannot change a carrier or radiation wave; you can only know what it is supposed to do and let it do it. That's enough.

This is very important. Vibrations having substituted for thinghood. Could it be said that you made an art form of vibrations?

Of energy.

An art form of energy?

Yes everything is energy. There is not anything that is not energy. You may say of a Minimal sculpture that the object itself is the art even though it may emit these energies. I would say it's the energy that's my art. Then it seemed to me that the object that was producing the energy was getting in the way. Isotopes, transmitters, etc. I chose to work with inert gas because there was not the constant presence of a small object or device that produced the art. Inert gas is a material that is imperceivable—it does not combine with any other element. Here is the place where the gas was released—the Mojave Desert. It goes "from measured volume to indefinite expansion"—as it says on my poster. That is what gas does. When released, it returns to

the atmosphere from where it came. It continues to expand forever in the atmosphere, constantly changing and it does all of this without anybody being able to see it. In the desert we released all kinds of gases: Neon and xenon, the so-called noble gases. The gas is purchased in glass flasks or tanks. The label on the Pyrex flask might read "2 liter xenon" —yet you see nothing. You have to trust the manufacturer. When we released a tank in the desert—in the middle of nowhere—it made a whistling sound. That's all we know about its being there.

Later I got involved with energy without an object-source of energy. I did that using mental energy. I did a "telepathic piece" for Seth Siegelaub's exhibition [1969] at Simon Fraser University in Vancouver. In the catalogue it states "During the exhibition I shall try to communicate telepathically a work of art, the nature of which is a series of thoughts; they are not applicable to language or image." I guess this was the first work I did that really did not have a place to be photographed. There was nothing visual that could be tied to it.

How do you feel about the missing aesthetic aspect? How does it affect you having either transcended or pushed aside the visual experience? Did you feel a sense of loss, as though you gave something up?

No, not at all. I like the word "transcend." I think you have to see it in those terms. Making art is not really important. Living is. In my mind art and living are so closely interlocked. Trying to be involved in living and in the world around me makes this satisfactory. It seems to me that you have to give up something for an advance you are making. For any new truth that you discover for yourself, you have to discard some favored old belief. I would like to get away from calling things art. Robbe-Grillet has a beautiful line: If art is going to be anything then it has got to be everything.

Fortunately—in recent years—the term "art" has lost any solid meaning. I guess if I call something art, I am saying: "Look at this thing, consider it carefully and that is all it means."

Does that mean that the act of perception per se might constitute the art?

No, you cannot get away so easily. I am using art to draw

attention to something. I much rather use the word "something" or "thing" or "What I do" than the word "art." If I call something "art," I am using the expression instead of saying: "Look at this."

Yet, in a certain frame of mind man can perceive anything as art. In the ideal state of mystic perception, Blake described it "Everything is seen for what it really is: infinite." Then there is no need of drawing attention to art, is there?

The mystical experience is closed to us. It is now, anyway. It is probably very close to revelation. Every once in a while the defenses of the mind break down and infinity rushes in. Then it closes up again.

Would the intentionality of the artist be necessary when infinity rushes in?

Yes, it is very fundamental. We talked about the world, we talked about things, but we avoided talking about people and how we relate to them. We cannot isolate ourselves. Art is an effort to relate to others. And in relation to other people it always has to be that way.

To understand my art, you do not have to understand any system that I developed, but you have to understand the category that I selected to call art. I did not really try to change something, I simply selected. . . .

I got involved with things intangible and immeasurable, physical, yet metaphysical in their effect. I wrote a letter to Charles Harrison of the Institute of Contemporary Art in London to include in any printed material for his show the idea for my piece: "THERE IS SOMETHING VERY CLOSE IN PLACE AND TIME, BUT NOT YET KNOWN TO ME." This was not just a title, but a feeling about something. Another piece went to the museum in Leverkusen, Germany, also concerned with something, which was searching for me and which needs me to reveal itself, but is unknown to me. Lucy Lippard's show in Seattle [1970] consisted of 100 index cards. So it was just on one of the index cards. There were quite a few pieces that tried to get at something. Yet because of the nature of something, it cannot be dealt with directly.

Would you care to tell how critics and collectors deal with your art?

There are no collectors, for there is nothing to collect.

And how does your work relate to the whole spectrum of contemporary art?

I feel it fits quite comfortably. Is there something that is not art? I must admit in my own mind, it's not really outside the stream, but in the riverbed together with the rest of the water.

What are your plans for your coming exhibition in Amsterdam?

My exhibition at the Art & Project Gallery in Amsterdam in December, '69, will last two weeks. I asked them to lock the door and nail my announcement to it, reading: "For the exhibition the gallery will be closed."

FREDERICK BARTHELME

DATE: February 21, 1970
SUBSTITUTION: 24

INSTEAD OF MAKING ART I ___filled___
out this form.

DATE: February 22, 1970

SUBSTITUTION: 25

INSTEAD OF MAKING ART I filled

out this form.

Art
**I AM NOT
NOR HAVE
I EVER BEEN
GREGORY BATTCOCK**

Art
**I AM NOT

NOR HAVE

I EVER BEEN

GREGORY BATTCOCK**

GREGORY BATTCOCK

I've been told by the authorities here to "write about art please you're supposed to be the art critic." Well, that's right and I don't see why there's a problem. Richard Kostelanetz just called me up to remind me of the Meredith Monk and Yvonne Rainer dance programs in February at the Billy Rose Theatre. I think Rainer is doing the most intelligent things that could happen in dance today. Someone called Saul Ostrow sent me a carbon copy of a letter which said only: I AM NOT NOR HAVE I EVER BEEN GREGORY BATTCOCK. That's very frightening and reminded me of what Jill Johnston said in last week's *Voice* about taking a subway ride and ending up in the lost and found. . . .

BERNHARD and HILLA BECHER
The Function

The function of cooling-towers is to cool off the cooling-water which has become warm in the progress of work. Cooling-water is used to bring down the temperature of liquids or gases or regain water otherwise lost through condensation.

Modern power stations have an average hourly water consumption of 100,000 cubic meters. Nowadays it is seldom possible to extract such huge water supplies from rivers or lakes without disturbing their biological structure. Mains-water is either insufficient or too expensive. The problem is solved relatively simply:

As soon as the water has completed the job of cooling (during which its temperature has risen a few degrees) it is piped into the lower part of the cooling-tower and, by means of a canal system, is distributed evenly over the complete bisection.

Spray-plates built into the bases of distributing canals spray the water in fine drops, which then drop through several layers of lattices. By checking the fall of the waterdrops the water is exposed as long as possible on as many surfaces as possible to the surrounding atmosphere.

Three processes take place successively:
1) The water radiates some of its heat into the air.
2) The warm air fuses the water and causes condensation-coldness.
3) The rising warm air and water mixture draws up cold air from below.

The cooled water is collected in a concrete basin beneath the tower and from there it repeats the complete process.

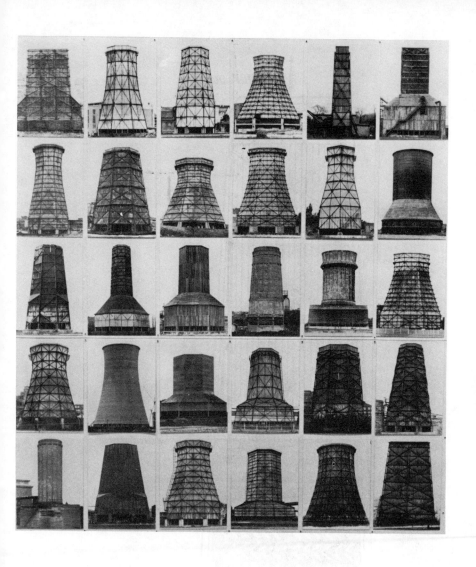

Anonymous sculpture, *Cooling Towers*. 1961–70.

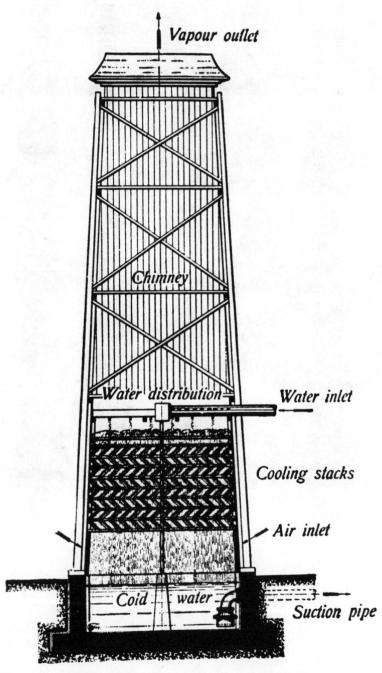

Vapour outlet

Chimney

Water distribution — Water inlet

Cooling stacks

Air inlet

Cold water

Suction pipe

Bernhard and Hilla Becher: *Houses (Fachwerkhäuser).* 1959–64.

MEL BOCHNER

Excerpts From Speculation [1967–1970]*

For a variety of reasons I do not like the term "conceptual art." Connotations of an easy dichotomy with perception are obvious and inappropriate. The unfortunate implication is of a somewhat magical/mystical leap from one mode of existence to another. The problem is the confusion of idealism and intention. By creating an original fiction, "conceptualism" posits its special nonempirical existence as a positive (transcendent) value. But no amount of qualification (or documentation) can change the situation. Outside the spoken word, no thought can exist without a sustaining support.

A fundamental assumption in much recent past art was that things have stable properties, i.e., boundaries. This seemingly simple premise became the basis for a spiraling series of conclusions. Boundaries, however, are only the fabrication of our desire to detect them . . . a trade-off between seeing something and wanting to enclose it. For example, what we attribute to objects as "constancy of size," during their progressive diminution when we walk away from them, is not a set of snapshot images gradually blending together. Concentration produces the illusion of consistency. Sight itself is prelogical and without constants (out of focus). The problem is that surrendering the stability of objects immediately subverts any control we think we have over situations. Consider the possibility that the need to identify art with objects is probably the outgrowth of the need to assign our feelings to the things that prompt them.

The "history of art" and the "history of painting and

* Reprinted from *Artforum* (May, 1970).

Compass: Orientation. 1968.

sculpture" are not the same, but merely coincident at some points.

Immediate experience will not cohere as an independent domain. Memories tend to be remains, not of past sensations, but past verbalizations. The discussion of much recent art has attempted the substitution of stimulus information for sensation (exterior vs. interiorization). This has not resolved discreteness with continuity. Perception of an object is generally preconceived as taking place within a point-by-point time. This disconnected time, a lingering bias of tense in language, restricts our experiencing the conjunction between object and observation. When this conjunction is acknowledged, "things" become indistinguishable from events. Carried to its conclusion, physicality, or what separates the material from the nonmaterial (the object from our observation), is merely a contextual detail.

A structure that concerns the nonobject oriented artist is the language that he uses to formulate his thoughts. There is nothing inherently antivisual about this pursuit. Works of art are not illustrations of ideas.

If, as it has been said, time presupposes a view of time, perception also includes its presuppositions. Perception is geared to cancel out whatever is stray or unaccountable. "Back-ground" is characterized negatively as the unclear, indistinct, and nonarticulated. But background is neither the margin nor fringe of the implicit. It is only through the function of its "opening out" that we are presented with a passage to the density of things. The realm of ideas is the operative link preceding any of the forms of objectness: it is an expanse of directions, not dimensions; of settings, not points; of regions, not planes; of routes, not distances. Beneath materiality are not merely facts but a radiation spreading out beyond dimensionality, involvement, and signification.

What if we were to think only about the place from which works of art enter our consciousness? Five possibilities come to mind:

1) what we look up at

2) what we look down upon

3) what we see straight on

4) what we are surrounded by

5) what is not seen by looking

(One dividend of such an approach could be the erasure from our minds of all vestiges of the listless "object quality" of paintings, or the leaden "specific materials" of sculpture.) We could then simply concentrate on where we are looking. Consideration of "where" implies more than an ontology of position. It suggests that differentiations by style need not be made and then transformed into values. All art exists as it exists within its own described set of conditions. The only esthetic question is recognition . . . re-cognition . . . thinking it again.

A desire to eliminate "furniture" from art is not nihilistic. What does initially appear "sterile" is an attitude that establishes nothing, produces little, and by its very nature cancels out results. Also there is the gratuitousness of being unwilling to transform the world or accumulate in it . . .

At the risk of appearing self-contradictory, I do not believe art is understood through intellectual operations, but rather that we intercept the outline of a certain manner of treating (being in) the world.

Thinking via the constant intervention of procedures, one over another, filters out the arbitrariness of conventional thought patterns. Any sort of in-formation or re-formation can be diverted by externally maintained constants. The fascination with seriality and modular form (which continues, disguised, in the work of many artists) made it possible, at one point, to clarify and distinguish the processes

involved in the realization of the work of art. Ordered proceduralism often led to an inversely proportional visual complexity. Suppression of internal relational concerns opened the way for the involvement with ideas beyond the concentricity of objects. It became apparent that the entire foundation of art experienced from a "point of view" was irrelevant to art of attenuated size or total surround, i.e., works without experienced centers. A case in point is the work made in and for a single place. Wall-works, for example, simply bypass double supports. Marks on the wall, here forward and in view, there only peripherally visible, held where they are by the wall's mass . . . spread *along* the surface. They cannot be "held," only seen. As such they are neither copy nor paradigm. Art of this nature is not secondly present. Its uniqueness (single placedness) is its coexistent unity with its own appearance.

Formalist art is predicated on a congruency between form and content. Any artist who considers this dichotomy either irreconcilable (or desirable) is no longer interested in formal relationships. For this artist the activity of making is not equivalent to the informing of content (a more appropriate word would be "intent"). Certain intents are capable of various equally viable realizations.

Imagination is a word that has been generally banned from the vocabulary of recent art. Associations with any notion of special power reserved for artists or of a "poetical world" of half-dreams seem particularly unattractive. There is, however, within the unspecified usage of the word a function that infuses the process of making and seeing art. The root word "image" need not be used only to mean representation (in the sense of one thing referring to something other than itself). To re-present can be defined as the shift in referential frames of the viewer from the space of events to the space of statements or vice versa. Imagining (as opposed to imaging) is not a pictorial preoccupation.

Imagination is a projection, the exteriorizing of ideas about the nature of things seen. It reproduces that which is initially without product. A good deal of what we are "seeing" we are, in this sense, actually imagining. There is an overlap in the mind of these two dissimilar activities. We cannot see what we cannot imagine.

One does not frequently think with his eyes closed, although what one is thinking at any moment need not be directly concerned with what one is looking at. A nonvisual thought (one without background) seems highly unlikely.

Ultimately, description as a critical method fails. Pretending to a nonsubjective rendering of the object, it cuts off the peripheral pressures of experience. When visual data is accepted as the only basis of apprehension, there is no possibility for an account of intentions. At the same time, descriptive self-enclosure does not create itself as its own sole recipient.

Would anything change if sensible things were conceived of as "across" space, rather than "in" space? First, objects would cease to be the locus of sight. Then, no longer centers in themselves, they would demand to be perceived as the organization by everything around them. What might result from this conjecture is a sense of trajectory rather than of identity. What common sense has always presented as a unity (objects) become only the negatives in a field of determinants. Opaque, yet fragmented, what is seen is only what stops my view beyond . . . it is in front of me but without being in depth. Profiled in this way, matter surrenders its obstinate chunkiness to reveal only a position in a cross section of orientations and levels, these levels merge on but one plane into dimensional sense data. And even on this plane, thought can efface them.

A procedural work of art is initiated without a set product

in mind. In a piece of this kind the interest is only in knowing that the procedures, step by step, have been carefully and thoroughly carried through. The specific nature of any result is contingent on the time and place of implementation, and is interesting as such. It is the "proceeding" that establishes it.

On approaching the threshold of nonenduring art, we can easily postulate an art of microseconds . . . but rarely see it. Why does art have to be any more distinct than peripheral vision? I do not mean this in the sense of "now-you-see-it-now-you-don't." I am imagining an art which by taking up all the expected requirements of our basic modes of perception would, in so doing, render itself invisible.

In the context of visual art what could the term "dematerialization" mean? I find that it contains an essential contradiction that renders it useless as an idea. The inherent weakness is revealed when the derivation of the term is examined. Tracing the origin of the idea leads one back to the basic confusion in the notion of "abstraction." All "abstract art" is premised on the belief in a first-level reality composed of constituent and separate qualities. In order to arrive at a truer "reality," the abstract artist must take apart this composite structure. The act of disjointure was to result in an intensification of the abstracted quality (color, shape, texture, etc.). This then became the material for further manipulation. The entire substructure of this concept is flawed. It simply is not possible to break things down into classifiable components, at least not without destroying the essential unity that is their existence. The blue of my typewriter is inseparable from its smooth surface. The blue-smooth surface was not created by combining a "blue" with a "smooth." Abstraction is an analytical method and not a reversible equation. One further step along this same line of reasoning yields "dematerialization." If all qualities are taken away, you have de(no)-materialization (components).

But given the evidence that abstraction itself is without credible grounds, can one derive from it a second level . . . a completely nonontological art? My disagreement with dematerialization goes beyond a squabble with terms. There is no art that does not bear some burden of physicality. To deny it is to descend to irony. Words set up circumstances for understanding, and this particular one only perpetuates old confusions. It is misleading to the intentions of artists finding different ways for art to come into being . . . and both how and how long it stays there.

EIGHT SETS "4-WALL"

MEL BOCHNER 1966

Mel Bochner: *Measurement Series: Group "C."* 1967.

Sandwichmen. Paris, 1968.

DANIEL BUREN

Beware! *

This text was written for the exhibition "Conception" at Leverkusen (subsequently reprinted by A 379089 of Antwerp) before I had seen the works that were "exhibited" there. My skepticism in certain respects was proved justified. Given that this text is neither a profession of faith nor a bible nor a model for others, but merely a reflection upon work in progress, I have wished, for this new context, to change certain words, delete or restate certain phrases or to go more thoroughly into certain particular points with respect to the original text. Alterations or additions to the original are set in italics and placed in square brackets.

I
WARNING

A concept may be understood as being "the general mental and abstract representation of an object." (See *Le Petit Robert Dictionary;* "an abstract general notion or conception"—*Dictionary of the English Language.*) Although this word is a matter for philosophical discussion, its meaning is still restricted; concept has never meant "horse." Now, considering the success that this word has obtained in art circles, considering what is and what will be grouped under this word, it seems necessary to begin by saying here what is meant by "concept" in para-artistic language.

We can distinguish [*four*] different meanings that we shall find in the various "conceptual" demonstrations, from which we shall proceed to draw [*four*] considerations that will serve as a warning.

1) *Concept = Project.* Certain works, which until now were considered only as rough outlines or drawings for works to be executed on another scale, will henceforth be raised to the rank of "concepts." That which was only a means becomes an end through the miraculous use of one word. There is absolutely no question of just any sort of

* Reprinted from *Studio International,* Vol. 179, No. 920 (May, 1970).

concept, but quite simply of an object that cannot be made life-size through lack of technical or financial means.

2) *Concept = Mannerism.* Under the pretext of concept the anecdotal is going to flourish again and with it, academic art. It will no longer of course be a question of representing to the nearest one the number of gilt buttons on a soldier's tunic, nor of picturing the rustling of the undergrowth, but of discoursing upon the number of feet in a kilometer, upon Mr. X's vacation on Popocatepetl or the temperature read at such and such a place. The "realistic" painters, whether it be Adolphe Bouguereau, painters of socialist realism, or Pop artists, have hardly acted otherwise under the pretext of striving after reality. [*In order, no doubt, to get closer to "reality," the "conceptual" artist becomes gardener, scientist, sociologist, philosopher, storyteller, chemist, sportsman.*] It is a way—still another—for the artist to display his talents as conjurer. In a way, the vague concept of the word "concept" itself implies a return to Romanticism.

[2a) *Concept = Verbiage. To lend support to their pseudocultural references and to their bluffing games, with a complacent display of questionable scholarship, certain artists attempt to explain to us what a conceptual art would be, could be, or should be—thus making a conceptual work. There is no lack of vulgarity in pretension. We are witnessing the transformation of a pictorial illusion into a verbal illusion. In place of unpretentious inquiry we are subjected to a hotchpotch of explanations and justifications that serve as obfuscation in the attempt to convince us of the existence of a thought. For these, conceptual art has become "verbiage art." They are no longer living in the twentieth century, but wish to revive the eighteenth.*]

3) *Concept = Idea = Art.* Lastly, more than one person will be tempted to take any sort of an "idea," to make art of it and to call it a "concept." It is this procedure which seems to us to be the most dangerous, because it is more difficult to dislodge, because it is very attractive, because it raises a problem that really does exist: how to dispose of the object? We shall attempt, as we proceed, to clarify this notion of object. Let us merely observe henceforth that it seems to us that to exhibit (*exposer*[1]) or set forth a concept

[1] Whether there is a material object or not, as soon as a thing, an idea, or a concept is removed from its context, it is indeed a question of its exposition, in the traditional sense of this term.

is, at the very least, a fundamental misconception right from the start and one which can, if one doesn't take care, involve us in a succession of false arguments. To exhibit a concept, or to use the word concept to signify art, comes to the same thing as putting the concept itself on a level with the object. This would be to suggest that we must think in terms of a "concept-object"—which would be an aberration.[2]

This warning appears necessary to us because if it can be admitted that [*these interpretations are not relevant for all representatives of this tendency*] we can affirm that at least nine-tenths of the works gathered together for [*the exhibition at Leverkusen*] (or its counterparts) [*relied on one of the four points*] raised above or even, for some people [*partook subtly of all four at once*]. They rely on the traditional and "evergreen" in art or, if you like, rely on idealism or utopianism, the original defects that art has not yet succeeded in eradicating.[3] We know from experience that at the time of a manifestation of this kind, people are only too quick to impose the image of the majority upon any work shown. In this particular case, this image will be approximately as described above, i.e., that of the new avant-garde, which has become "conceptual." This is nothing more than to identify, in a more or less new form, the *prevailing ideology.* Therefore, *although concerned with confronting problems,* let us henceforth suspend judgment of the way in which they are approached or solved in the majority of cases. Moreover our present task is not to solve any enigmas, but rather to try to understand/to recognize the problems that arise. It is much more a question of a method of work than the proposal of a new intellectual gadget.

II
WHAT IS THIS WORK?

Vertically striped sheets of paper, the bands of which are 8.7 cms wide, alternate white and colored, are stuck over internal and external surfaces: walls, fences, display windows, etc.; and/or cloth/canvas support, vertical stripes,

[2] This approach is not only aberrant (nonsense) but typically regressive, considering that the very concepts of art, of works of art . . . are in course of being dissolved.

[3] To deny this would be to call in question all the notions sustaining the word art.

white and colored bands each 8.7 cms, the two ends covered with dull white paint.

I record that this is my work for the last four years, without any evolution or way out. This is the past: it does not imply either that it will be the same for another ten or fifteen years or that it will change tomorrow.

The perspective we are beginning to have, thanks to these past four years, allows a few considerations of the direct and indirect implications for the very conception of art. This apparent break (no research, or any formal evolution for four years) offers a platform that we shall situate at zero level, when the observations both internal (conceptual transformation as regards the action/praxis of a similar form) and external (work/production presented by others) are numerous and rendered all the easier as they are not invested in the various surrounding movements, but are rather derived from their absence.

Every act is political and, whether one is conscious of it or not, the presentation of one's work is no exception. Any production, any work of art is social, has a political significance. We are obliged to pass over the sociological aspect of the proposition before us due to lack of space and considerations of priority among the questions to be analyzed.

The points to be examined are described below and each will require to be examined separately and more thoroughly later. [*This is still valid nowadays.*]

a) *The Object, the Real, Illusion.* Any art tends to decipher the world, to visualize an emotion, nature, the subconscious, etc. Can we pose a question rather than replying always in terms of hallucinations? This question would be: can one create something that is real, nonillusionistic, and therefore not an art-object? One might reply—and this is a real temptation for an artist—in a direct and basic fashion to this question and fall instantly into one of the traps mentioned [*in the first section*]; i.e., believe the problem *solved,* because it was *raised,* and [*for example*] present no object but a concept. This is responding too directly to need, it is mistaking a desire for reality, it is making like an artist. In fact, instead of questioning or acquainting oneself with the problem raised, one provides a solution, and what a solu-

tion! One avoids the issue and passes on to something else. Thus does art progress from form to form, from problems raised to problems solved, accruing successive layers of concealment. To do away with the object as an illusion—the real problem—through its replacement by a concept [*or an idea*]—utopian or ideal(istic) or imaginary solution—is to believe in a moon made of green cheese, to achieve one of those conjuring tricks so beloved of twentieth-century art. Moreover it can be affirmed, with reasonable confidence, that as soon as a concept is announced, and especially when it is "exhibited as art," under the desire to do away with the object, *one merely replaces it* in fact. The exhibited concept becomes *ideal-object,* which brings us once again to art as it is, i.e., the illusion of something and not the thing itself. In the same way that writing is less and less a matter of verbal transcription, painting should no longer be the vague vision/illusion, even mental, of a phenomenon (nature, subconsciousness, geometry . . .) but *VISUALITY of the painting itself.* In this way we arrive at a notion that is thus allied more to a method and not to any particular inspiration; a method which requires—in order to make a direct attack on the problems of the object properly so-called—that painting itself should create a mode, a specific system, that would no longer direct attention, but that is "produced to be looked at."

b) *The Form.* As to the internal structure of the proposition, the contradictions are removed from it; no "tragedy" occurs on the reading surface, no horizontal line, for example, chances to cut through a vertical line. Only the imaginary horizontal line of delimitation of the work at the top and at the bottom "exists," but in the same way that it "exists" only by mental reconstruction, it is mentally demolished simultaneously, as it is evident that the external size is arbitrary (a point that we shall explain later on).

The succession of vertical bands is also arranged methodically, always the same [*x,y,x,y,x,y,x,y,x,y,x, etc.* . . .], thus creating no composition on the inside of the surface or area to be looked at, or, if you like, a minimum or zero or neutral composition. These notions are understood in relation to art in general and not through internal considerations. This neutral painting however is not freed from

obligations. On the contrary, thanks to its neutrality or absence of style, it is extremely rich in information about itself (its exact position as regards other work) and especially information about other work; thanks to the absence of any formal problem its potency is all expended upon the realms of thought. One may also say that this painting no longer has any plastic character, but that it is *indicative* or *critical*. Among other things, indicative/critical of its own process. This zero/neutral degree of form is "binding" in the sense that the total absence of conflict eliminates all concealment (all mythification or secrecy) and consequently brings silence. One should not take neutral painting for uncommitted painting.

Lastly, this formal neutrality would not be formal at all if the internal structure of which we have just spoken (vertical white and colored bands) was linked to the external form (size of the surface presented to view). The internal structure being immutable, if the exterior form were equally so, one would soon arrive at the creation of a quasi-religious archetype which, instead of being neutral, would become burdened with a whole weight of meanings, one of which— and not the least—would be as the idealized image of neutrality. On the other hand, the continual variation of the external form implies that it has no influence on the internal structure, which remains the same in every case. The internal structure remains uncomposed and without conflict. If, however, the external form or shape did not vary, a conflict would immediately be established between the combination or fixed relationship of the bandwidths, their spacing (internal structure), and the general size of the work. This type of relationship would be inconsistent with an ambition to avoid the creation of an illusion. We would be presented with a problem all too clearly defined—here that of neutrality to zero degree—and no longer with the thing itself posing a question, in its own terms.

Finally, we believe confidently in the validity of a work or framework questioning its own existence, presented to the eye. The framework, which we have just analyzed clinically, has in fact no importance whatsoever in terms of form or shape; it is at zero level, a minimum but *essential* level. We shall see later how we' shall work to cancel out the form

itself so far as possible. In other words, it is time to assert *that formal problems have ceased to interest us.* This assertion is the logical consequence of actual work produced over four years where the formal problem was forced out and disqualified as a pole of interest.

Art is the form that it takes. The form must unceasingly renew itself to insure the development of what we call new art. A change of form has so often led us to speak of a new art that one might think that inner meaning and form were/are linked together in the mind of the majority—artists and critics. Now, if we start from the assumption that new, i.e., "other," art is in fact never more than the same thing in a new guise, the heart of the problem is exposed. To abandon the search for a new form at any price means trying to abandon the history of art as we know it: it means passing from the *Mythical* to the *Historical,* from the *Illusion* to the *Real.*

c) *Color.* In the same way that the work which we propose could not possibly be the image of some thing (except itself, of course), and for the reasons defined above could not possibly have a finalized external form, there cannot be one single and definitive color. The color, if it was fixed, would mythify the proposition and would become the zero degree of color X, just as there is navy blue, emerald green or canary yellow.

One color and one color only, repeated indefinitely or at least a great number of times, would then take on multiple and incongruous meanings.[4] All the colors are therefore used simultaneously, without any order of preference, but systematically.

That said, we note that if the problem of form (as pole of interest) is dissolved by itself, the problem of color, considered as subordinate or as self-generating at the outset of the work and by the way it is used, is seen to be of great importance. The problem is to divest it of all emotional or anecdotal import.

[4] We may here mention the false problem raised/solved by the monochrome: ". . . The monochrome canvas as subject-picture refers back—and refers back in the end only to that metaphysical background against which are outlined the figures of the type of painting called realist, which is really only illusionist." Marcelin Pleynet in *Les Lettres Françaises,* No. 1177.

We shall not further develop this question here, since it has only recently become of moment and we lack the required elements and perspective for a serious analysis. At all events, we record its existence and its undeniable interest. We can merely say that every time the proposition is put to the eye, only one color (repeated on one band out of two, the other being white) is visible and that it is without relation to the internal structure or the external form that supports it and that, consequently, it is established a priori that: white = red = black = blue = yellow = green = violet, etc.

d) *Repetition.* The consistency—i.e., the exposure to view in different places and at different times, as well as the personal work, for four years—obliges us to recognize manifest visual repetition at first glance. We say at "first glance," as we have already learned from sections (a) and (b) that there are divergencies between one work and another; however, the essential, that is to say the internal, structure remains immutable. One may therefore, with certain reservations, speak of repetition. This repetition provokes two apparently contradictory considerations: on the one hand, the reality of a certain form (described above), and on the other hand, its *canceling-out* by successive and identical confrontations, which themselves negate any originality that might be found in this form, despite the systematization of the work. We know that a single and unique "picture" as described above, although neutral, would be charged by its very uniqueness with a symbolic force that would destroy its vocation of neutrality. Likewise by repeating an identical form, or identical color, we would fall into the pitfalls mentioned in sections (b) and (c). Moreover we would be burdened with every unwanted religious tension if we undertook to idealize such a proposition or allowed the work to take on the ancedotal interest of a test of strength in response to a stupid bet.

There remains only one possibility; the repetition of this neutral form, with the divergencies we have already mentioned. This repetition, thus conceived, has the effect of reducing to a minimum the potency, however slight, of the proposed form such as it is, of revealing that the external

form (shifting) has no effect on the internal structure (alternate repetition of the bands) and of highlighting the problem raised by the color in itself. This repetition also reveals in point of fact that visually there is *no formal evolution*—even though there is a change—and that, in the same way that no "tragedy" or composition or tension is to be seen in the clearly defined scope of the work exposed to view (or presented to the eye), no tragedy or tension is perceptible in relation to the creation itself. The tensions abolished in the very surface of the "picture" have also been abolished—up to now—in the time category of this production. *The repetition is the ineluctable means of legibility of the proposition itself.*

This is why, if certain isolated artistic forms have raised the problem of neutrality, they have never been pursued in depth to the full extent of their proper meaning. By remaining "unique" they have lost the neutrality we believe we can discern in them. (Among others, we are thinking of certain canvases by Cézanne, Mondrian, Pollock, Newman, Stella.)

Repetition also teaches us that there is no perfectibility. A work is at zero level or it is not at zero level. To approximate means nothing. In these terms, the few canvases of the artists mentioned can be considered only as empirical approaches to the problem. Because of their empiricism they have been unable to divert the course of the "history" of art, but have rather strengthened the idealistic nature of art history as a whole.

e) *Differences.* With reference to the preceding section, we may consider that repetition would be the right way (or one of the right ways) to put forward our work in the internal logic of its own endeavor. Repetition, apart from what its use revealed to us, should, in fact, be envisaged as a "method" and not as an end. A method that definitively rejects, as we have seen, any repetition of the mechanical type, i.e., the geometric repetition (superimposable in every way, including color) of a like thing (color + form/shape). To repeat in this sense would be to prove that a single example already has an energy that denies all neutrality, and that repetition could change nothing.

One rabbit repeated 10,000 times would give no notion

whatever of neutrality or zero degree, but eventually the identical image, 10,000 times, of the same rabbit. The repetition that concerns us is therefore fundamentally the presentation of the same thing, but under an objectively *different* aspect. To sum up, manifestly it appears to us of no interest always to show precisely the same thing and from that to deduce that there is repetition. The repetition that interests us is that of a method and not a mannerism (or trick): it is a repetition with differences. One could even say that it is these differences that make the repetition, and that it is not a question of doing the same in order to say that it is identical to the previous—which is a tautology (redundancy)—but rather a *repetition of differences with a view to a same* (*thing*). [*This repetition is an attempt to cover, little by little, all the avenues of inquiry. One might equally say that the work is an attempt to close off in order the better to disclose.*]

[e2] *Canceling-out. We should like to return to the idea of canceling-out, briefly touched upon in sections* (b) *and* (d).

The systematic repetition that allows the differences to become visible each time is used as a method and not considered as an end, in awareness of the danger that, in art, a form/thing—since there is a form/thing—can become, even if it is physically, aesthetically, objectively insignificant, an object of reference and of value. Furthermore, we can affirm that objects, apparently insignificant and reduced, are more greatly endangered than others of more elaborate appearance, and this is a result of (or thanks to) the fact that the object/idea/concept of the artist is only considered from a single viewpoint (a real or ideal viewpoint, cf. section [g]) *and with a view to their consummation in the artistic milieu.*

A repetition, which is ever divergent and nonmechanical, used as a method, allows a systematic closing-off *and, in the same moment that things are closed off* (lest we should omit anything from our attempts at inquiry) *they are* canceled out. Canceled out through lack of importance. *One cannot rest content once and for all with a form that is insignificant and impersonal in itself—we have just exposed the danger of it. We know from experience, that is to say*

theoretically, that the system of art can extrapolate by licensing every kind of impersonal aspect to assume the role of model. Now, we can have no model, rest assured, unless it is a model of the model itself. Knowing what is ventured by the impersonal object, we must submit it—our method—to the test of repetition. This repetition should lead to its disappearance/obliteration. Disappearance in terms of significant form as much as insignificant form.

The possibility of the disappearance of form as a pole of interest—disappearance of the object as an image of something—is "visible" in the single work, but should also be visible through the total work, that is to say in our practice according to and in every situation.

What is being attempted, as we already understand, is the elimination of the imprint of form, together with the disappearance of form (of all form). This involves the disappearance of "signature," of style, of recollection/derivation. A unique work (in the original sense), by virtue of its character, will be conserved. The imprint exists in a way, which is evident/insistent at the moment when it is, like form itself, a response to a problem or the demonstration of a subject or the representation of an attitude. If, however, the "print" of the imprint presents itself as a possible means of canceling-out and not as something privileged/conserved—in fact, if the imprint, rather than being the glorious or triumphant demonstration of authorship, appears as a means of questioning its own disappearance/insignificance—one might then speak of canceling-out indeed; or, if you like, destruction of the imprint, as a sign of any value, through differentiated repetition of itself rendering void each time anew, or each time a little more, the value that it might previously have maintained. There must be no letup in the process of canceling-out, in order to "blow" the form/thing, its idea, its value, and its significance to the limits of possibility.

We can say (cf. section [f]) that the author/creator (we prefer the idea of "person responsible" or "producer") can "efface himself" behind the work that he makes (or that makes him), but that this would be no more than a good intention, consequent upon the work itself (and hence a minor consideration), unless one takes into consideration

the endless canceling-out of the form itself, the ceaseless posing of the question of its presence; and then that of its disappearance. This going and coming, once again non-mechanical, never bears upon the succeeding stage in the process. Everyday phenomena alone remain perceptible, never the extraordinary.

e3) *Vulgarization.* The canceling-out, through successive repetitions in different locations of a proposition, of an identity that is constant by virtue of its difference in relation to a sameness, hints at that which is generally considered typical of a minor or bad art, that is to say vulgarization *considered here as a method. It is a question of drawing out from its respectable shelter of originality or rarity a work which, in essence, aims at neither respect nor honors. The canceling-out or the disappearance of form through repetition gives rise to the appearance, at the same moment, of profuseness and ephemerality. The rarefaction of a thing produced augments its value (salable, visual, palpable . . .). We consider that the "vulgarization" of the work that concerns us is a matter of necessity, due to the fact that this work is made manifest only that it shall have being, and disappears in its own multiple being.*

In art, banality soon becomes extraordinary. The instances are numerous. We consider that at this time the essential risk that must be taken—a stage in our proposition—is the vulgarization of the work itself, in order to tire out every eye that stakes all on the satisfaction of a retinal (aesthetic) shock, however slight. The visibility of this form must not attract the gaze. Once the dwindling form/imprint/gesture has been rendered impotent/invisible, the proposition has/will have some chance to become dazzling. The repetition of a neutral form, such as we are attempting to grasp and to put into practice, does not lay emphasis upon the work, but rather tends to efface it. We should stress that the effacement involved is of interest to us insofar as it makes manifest, once again, the disappearance of form (in painting) as a pole of attraction of interest, that is to say makes manifest our questioning of the concept of the painting in particular and the concept of art in general.

This questioning is absolutely alien to the habits of responding, implies thousands of fresh responses, and implies

therefore the end of formalism, the end of the mania for responding (art).

Vulgarization through repetition is already calling in question the further banality of art.]

f) *Anonymity.* From the [*seven*] preceding sections* there emerges a relationship which itself leads to certain considerations; this is the relationship that may exist between the "creator" and the proposition we are attempting to define. First fact to be established: *he is no longer the owner of his work.* Furthermore, it is not *his* work, but *a* work. The neutrality of the purpose—"painting as the subject of painting"—and the absence from it of considerations of style forces us to acknowledge a certain anonymity. This is obviously not anonymity in the person who proposes this work, which once again would be to solve a problem by presenting it in a false light—why should we be concerned to know the name of the painter of the Avignon *Pietà*—but of *the anonymity of the work itself as presented.* This work being considered as common property, there can be no question of claiming the authorship thereof, possessively, in the sense that there are authentic paintings by Courbet and valueless forgeries. As we have remarked, the projection of the individual is nil; we cannot see how he could claim his work as *belonging* to him. In the same way we suggest that the same proposition made by X or Y would be identical to that made by the author of this text. If you like, the study of past work forces us to admit that there is no longer, as regards the form defined above—when it is presented—any truth or falsity in terms of conventional meaning that can be applied to both these terms relating to a work of art.[5] [*The making of the work has no more than a relative interest, and in consequence he who makes the work has no more than a relative, quasi-anecdotal interest and cannot at any time make use of it to glorify "his" product.*] It may also be said that the work of which we speak, because neutral/anonymous, is indeed the work of someone, but that this someone has no importance whatsoever [*since he never reveals himself*], or, if you like, the im-

* Identified by the letters a, b, c, d, e, e2, e3.—Ed.

[5] See "Buren or Toroni or No Matter Who," demonstration, Lugano, December, 1967.

portance he may have is totally archaic. Whether he signs "his" work or not, it nevertheless remains anonymous.

g) *The Viewpoint—the Location.* Lastly, one of the external consequences of our proposition is the problem raised by the location where the work is shown. In fact the work, as it is seen to be without composition and as it presents no accident to divert the eye, becomes itself the accident in relation to the place where it is presented. The indictment of any form considered *as such,* and the judgment against such forms on the facts established in the preceding paragraphs, leads us to question the finite space in which this form is seen. It is established that the proposition, in whatever location it be presented, does not "disturb" that location. The place in question appears as it is. It is seen in its actuality. This is partly due to the fact that the proposition is not distracting. Furthermore, being only its own subject matter, its own location is the proposition itself, which makes it possible to say, paradoxically: the proposition in question "has no real location."[6]

In a certain sense, one of the characteristics of the proposition is to reveal the "container" in which it is sheltered. One also realizes that the influence of the location upon the significance of the work is as slight as that of the work upon the location.

This consideration, in course of work, has led us to present the proposition in a number of very varied places. If it is possible to imagine a constant relationship between the container (location) and the contents (the total proposition), this relationship is always annulled or reinvoked by the next presentation. This relationship then leads to two inextricably linked although apparently contradictory problems:

i) revelation of the location itself as a new space to be deciphered;

ii) the questioning of the proposition itself, insofar as its repetition (see sections [d] and [e]) in different "contexts," visible from different viewpoints, leads us back to the central issue: What is exposed to view? What is the nature of it? The multifariousness of the locations where the proposition is visible permits us to assert the unassailable persistence

6 See Michel Claura in *Les'Lettres Françaises,* No. 1277.

that it displays in the very moment when its nonstyle appearance merges it with its support.

It is important to demonstrate that while remaining in a very well-defined cultural field—as if one could do otherwise—it is possible to go outside the cultural location in the primary sense (gallery, museum, catalogue . . .) without the proposition, considered as such, immediately giving way.[7] This strengthens our conviction that the work proposed, insofar as it raises the question of viewpoint, is posing what is in effect a new question, since it has been commonly assumed that the answer follows as a matter of course.

We cannot get bogged down here in the implications of this idea: we will merely observe for the record that all the works that claim to do away with the object (Conceptual or otherwise) are essentially dependent *upon the single viewpoint* from which they are "visible," a priori considered (or even not considered at all) as ineluctable. A considerable number of works of art (the most exclusively idealist, e.g., Ready-mades of all kinds) "exist" only because the location in which they are seen is taken for granted as a matter of course.

In this way, the location assumes considerable importance by its fixity and its inevitability; becomes the "frame" (*and the security that presupposes*) at the very moment when they would have us believe that what takes place inside shatters all the existing frames (manacles) in the attaining of pure "freedom." A clear eye will recognize what is meant by freedom in art, but an eye that is a little less educated will see better what it is all about when it has adopted the following idea: that the location (outside or inside) where a work is seen is its frame (its *boundary*).

III
PREAMBLE

One might ask why so many precautions must be taken instead of merely putting one's work out in the normal fashion, leaving comment to the critics and other professional gossip columnists. The answer is very simple: complete rupture

[7] As an example and by comparison, what has become of Duchamp's urinal since it was returned to the public lavatories?

with art—such as it is envisaged, such as it is known, such as it is practiced—has become the only possible means of proceeding along the path of no return upon which thought must embark; and this requires a few explanations. This rupture requires as a first priority the revision of the history of art as we know it, or, if you like, its radical dissolution. Then if one rediscovers any *durable and indispensable criteria* they must be used not as a release from the need to imitate or to sublimate, but as a [*reality*] that should be restated. A [*reality*] in fact which, although already "discovered" would have to be challenged, therefore to be created. For it may be suggested that, at the present time [*all the realities*] that it has been possible to point out to us or that have been recognized, are not *known.* To recognize the existence of a problem certainly does not mean the same as to know it. Indeed, if some problems have been solved empirically (or by rule of thumb), we cannot then say that we know them, because the very empiricism that presides over this kind of discovery obscures the solution in a maze of carefully maintained enigmas.

But artworks and the practice of art have served throughout, in a parallel direction, to signal the existence of certain problems. This recognition of their existence can be called practice. The exact knowledge of these problems will be called theory (not to be confused with all the aesthetic "theories" that have been bequeathed to us by the history of art).

It is this *knowledge* or *theory* that is now indispensable for a perspective upon the rupture—a rupture that can then pass into the realm of fact. *The mere recognition* of the existence of pertinent problems *will not suffice for us.* It may be affirmed that all art up to the present day has been created on the one hand only *empirically* and on the other out of idealistic thinking. If it is possible to think again or to think and create theoretically/scientifically, the *rupture* will be achieved and thus the word "art" will have lost the meanings—numerous and divergent—which at present encumber it. We can say, on the basis of the foregoing, that the rupture, if any, can be (can only be) epistemological. This rupture is/will be the resulting logic of a theoretical work at the moment when the history of art (which is still to be

made) and its application are/will be envisaged theoretically: theory and theory alone, as we well know, can make possible a revolutionary practice. Furthermore, not only is/will theory be indissociable from its own practice, but again it may/will be able to give rise to other original kinds of practice.

Finally, as far as we are concerned, *it must be clearly understood that when theory is considered as producer/creator, the only theory or theoretic practice is the result presented/the painting* or, according to Althusser's definition: "Theory: a specific form of practice."

We are aware that this exposition of facts may be somewhat didactic; nevertheless we consider it indispensable to proceed in this way at this time.

VICTOR BURGIN

*Situational Aesthetics**

Some recent art, evolving through attention both to the conditions under which objects are perceived and to the processes by which aesthetic status is attributed to certain of these, has tended to take its essential form in message rather than in materials. In its logical extremity this tendency has resulted in a placing of art entirely within the linguistic infrastructure, which previously served merely to support art. In its less hermetic manifestations art as message, as "software," consists of sets of conditions, more or less closely defined, according to which particular concepts may be demonstrated. This is to say, aesthetic *systems* are designed, capable of generating objects, rather than individual objects themselves. Two consequences of this work process are: the specific nature of any object formed is largely contingent upon the details of the situation for which it is designed; through attention to time, objects formed are intentionally located partly in real, exterior space and partly in psychological, interior space.

Conceptual elements in a work may to some extent be conceived of, and accounted for, through analogy with the experience of substantial elements. Consider these instructions: suppose an interior wall of a room to be concealed by a skin. The skin is parallel with and an eighth-inch above the surface it conceals. The color of the skin simulates that of the concealed surface.

The preceding paragraph is not intended as an object in its own right, although it could be considered as such,[1] but "objects" may be generated through the perceptual behavior it recommends. The existing substances of the room serve to locate and particularize the object and no new materials are introduced. An immaterial object is created, which is solely a function of perceptual behavior, but which

* Reprinted from *Studio International,* Vol. 178, No. 915 (October, 1969).
[1] See: editorial *Art-Language,* Vol. 1, No. 1 (May 1969).

yet inducts attributes of physicality from its material setting. In "fitting" the Conceptual elements into this setting an act of attention is required that is similar to the act of handling material substances—it is styled by kinesthetic analogy.

In moving through real, "sensorial," space we may touch immediately near objects. Distant objects in real space are "touched" in the mind (we say the mind "reaches out"). The manner, therefore, in which we make our mental approach to a distant object of attention is styled through analogy with, and expectation of, the bodily experience of near objects. This mode of appreciation, learned in exterior, sensorial space, is applied when we negotiate interior, psychological space. Kinesthetic analogy then, an understanding in terms of body, is constant to our reception of perceptual experience, which shifts freely between sensorial and psychological data in the life-world "tangled, muddy, and perplexed," which precedes the ordering of experience.

We exercise discrimination toward perceptual fields. At the level of zero discrimination our experience is nonobjective and meaningless, "things" have not come into being. At the level of optimum discrimination for practical living, objects are identified and meaning attributed. But both primary experience and pragmatic interpretation are simply modes of consciousness, alternative states of awareness, and as such may be conceived of as points along a psychosensorial continuum. Between these points, to pursue the schematic analogy, lie all degrees of discrimination.

Schematically and in terms of discrimination, any path of consciousness through time might be represented as a meander. Attention to objects "out there" in the material world is constantly subverted by the demands of memory. Willful concentration is constantly dissolving into involuntary association. Even beyond familiar types of conscious association there are more subversive mechanisms at work: ". . . we now have direct evidence that signals become distributed within the input system. What we see . . . is not a pure and simple coding of the light patterns that are focused on the retina. Somewhere between the retina and the visual cortex the inflowing signals are modified to provide information that is already linked to a learned response. . . . Evi-

dently what reaches the visual cortex is evoked by the external world but is hardly a direct or simple replica of it."[2]

Accepting the shifting and ephemeral nature of perceptual experience, and if we accept that both real and conceptual objects are appreciated in an analogous manner, then it becomes reasonable to posit aesthetic objects that are located partly in real space and partly in psychological space. Such a placing of aesthetic objects however involves both a revised attitude toward materials and a reversal of function between these materials and their context.

Cage is hopeful in claiming, "We are getting rid of ownership, substituting use";[3] attitudes toward materials in art are still informed largely by the laws of conspicuous consumption, and aesthetic commodity hardware continues to pile up whereas utilitarian objects, whose beauty might once have been taken as conclusive proof of the existence of God, spill in inconceivable profusion from the cybernated cornucopias of industry. Each day we face the intractability of materials that have outstayed their welcome. Many recent attitudes to materials in art are based in an emerging awareness of the interdependence of all substances within the ecosystem of earth. The artist is apt to see himself not as a creator of new material forms but rather as a coordinator of existing forms, and may therefore choose to *subtract* materials from the environment. As art is being seen increasingly in terms of behavior so materials are being seen in terms simply of quantity rather than of quality.

Life exists by virtue of the one-sixth of one percent of impurities that exists in a universe composed mainly of hydrogen (about ninety percent) and helium (about ten percent). Viewed from this tangent, all artifacts may be seen as belonging to a continuum of forms of common elements. Consequently, a painting could be said to represent a point of particular cultural significance located in an elemental continuum somewhere between geological and organic forms and gases and dust. Although obviously irrelevant to

[2] Karl H. Pribram, "The Neurophysiology of Remembering," *Scientific American* (January, 1969).

[3] John Cage, *A Year from Monday* (Middletown, Conn.: Wesleyan University Press, 1969).

some of the more sophisticated aspects of connoisseurship, such an attitude toward materials does enable us to view their use simply in terms of their suitability for a situation— in a given context, some will seem more appropriate than others.

Once materials are selected according to largely fortuitous criteria, depending on their location, their individual status is diminished. The identification of art relies upon the recognition of cues that signal that the type of behavior termed aesthetic appreciation is to be adopted.[4] These cues help form a context that reveals the art-object. The object itself, in being displayed, may be termed overt and in the case of the visual arts it has been predominantly substantial. Any attempt to make an "object" of nonovert and insubstantial conceptual forms demands that substantial materials located in exterior space-time be used in a manner that subverts their "objectness" in order to identify them as "situational cues."[5]

Perceptual fields are not experienced as objects in themselves. Perception is a continuum, a precipitation of event fragments decaying in time, above all a *process.* An object analogue may, however, be posited by locating points within the perceptual continuum. Two rope triangles placed in Greenwich Park earlier this year represent an attempt to "parenthesize" a section of perceptual experience in time. General instructions for this work are:

1) Two units coexist in time.

2) Spatial separation is such that units may not simultaneously be directly perceived.

3) Units are isomorphic to the degree that an encounter

[4] It may no longer be assumed that art, in some mysterious way, resides in materials. Attempts to determine the necessary and sufficient conditions of aesthetic structure have failed from an emphasis upon the object rather than upon the perceiver. The implications of a redirection of attention, from object to perceiver, are extensive. It may now be said that an object becomes, or fails to become, a work of art in direct response to the inclination of the perceiver to assume an appreciative role. As Morse Peckham has put it, ". . . art is not a category of perceptual fields but of role-playing."

[5] Morse Peckham, *Man's Rage for Chaos. Biology, Behaviour, and the Arts* (New York: Schocken, 1967).

with a second unit is likely to evoke recollection of the first.

By the above definition the units may be said to bracket the perceptual data subjectively experienced between them. The "object," therefore may be defined as consisting of three elements: First unit. Recollection of intervening space-time. Second unit.

The first triangle in Greenwich Park was constructed using about 100 feet of ¼ inch rope held in tension between three 6 by ¼ inch wire-strainers driven into the ground so that only the circular "eyes" projected above the surface. The rope was threaded through the eyes, pulled taut, and knotted. A second triangle was constructed in a similar manner on an opposite side of the park from the first. The two triangles were equilateral, both measuring 36 feet on each side, and sited so that neither could be seen from the other and so that neither could be seen from any great distance. This latter condition was established by the selection of gently undulating localities, the points of the triangles touching the slopes of a depression with the ropes between passing freely through space a few inches above the ground. The intention of this positioning was that the triangles should "come into being" gradually, in an additive fragmentary fashion, as they were approached. Their position within view of a footpath increased the probability of an optimum reading being effected.

The triangles were serially ordered in space-time. Invariance in their reading, and therefore the apparent congruence of two actually dissimilar perceptual fields, was insured by the familiarity of the equilateral triangle as a configurational archetype. Encounter with the first triangle was not particularly notable, the materials used are commonplace and the handling of them eschewed craft considerations. It is conceivable that the first triangle might enter consciousness at a subliminal level (ropes are low in the hierarchy of sensory experiences offered by Greenwich Park). Encounter with the second triangle however emphasized recognition of the first by its involuntary recall. The intention was that the recollected image of the first configuration would be mentally brought forward and superimposed upon the configuration immediately available to the retina. Conscious-

ness would be sent back through its memory data assembling en route an object analogue composed of recalled images, the relationships between these fragments to be governed by personal associative propensities. The life of this conceptual element might be brief though repeated path-tracing between the two cues would probably favor a particular sequence of forms and impress them on the memory.

Because of the emphasis placed upon the perceiver's role in the formation of the "object" the specific nature of any such "object" is highly subjective. The required mode of attention would involve a mind "out of focus," a self-induced suspension of cognition in which experience is emotive but meaningless. To focus, like this, upon preobjective experience is to be aware of movement, and attention to motion reveals the ephemeral, emphasizes the inconstant: "The invariant component in a transformation carries information about an object and the variant component carries other information, for example, about the relation of the perceiver to the object. When an observer attends to certain invariants he perceives objects; when he attends to certain variants he has sensations."[6] If we suppose a consistently non-cognitive response to experience by an individual observing only the variant in his perception, then the only object of that individual's attention would be his "life object" as he passively observes the perpetually present modulations in his visual field. Conceptually, the life object is equivalent to any individual's total perceptual experience. However, the notion of an object assumes an exterior viewpoint. From "inside," subjective experience is a *context,* within which objects are encountered rather than an object. Nevertheless, the idea of all of one's perceptual experience as a single object does establish a high degree of latitude in the naming of objects as subdivisions within the subjectively experienced perceptual continuum. A more or less gratuitous designation of objects is possible as all perceptual data may be fitted into the common matrix of interval and duration.

Visual information concerning duration is gained, as it is

6 James J. Gibson, "Constancy and Invariance in Perception," *The Nature and Art of Motion,* ed. Gyorgy Kepes (Studio Vista, 1965).

gained when we observe motion, from observations of shift in perceptual field. In traveling past an object we are presented with an apparent configurational evolution from which we may abstract a number of discrete states. Comparison of expired configurations with the configuration of the moment tells us we are in motion relative to the object. An exercise of a similar nature is involved when we observe change in a place to which we have returned after an absence, we compare and contrast past and present configurations, or more accurately, we superimpose a memorized configuration upon a configuration present to the retina. Pragmatically, within this complex of shifting appearances, we have workable systems of establishing space-time coordinates for navigation and prediction, but true locations exist only in the abstract as points of zero dimensions. Locations such as those given by the National Grid are fixed by definition, but the actual spaces to which they refer are in continual flux and so impossible to separate from time.

Time, in the perception of exterior events, is the observation of succession linked with muscular-navigational memories—a visceral identification with change. Similarly kinesthetic modes of appreciation are applied to the subjective transformation of these events in interior time and in recollection. All behavior has these space-time parameters in common. To distinguish, therefore, between "arts of space" and "arts of time"[7] is literally unrealistic. The misconception is based in materialism, it springs, again, from a focus upon the *object* rather than upon the behavior of the perceiver. Theatre and cinema are not arts of "time" but arts of *theatrical* and *cinematic* time, governed by their own conventions and the limitations of their hardware. The Parthenon is not "timeless" but, simply, set in *geological* time. It is a mistake to refer to "time" as if it were singular and absolute. A full definition of the term would require a plurality of times and would accommodate such contrasting scales as the times of galaxies and of viruses. The current

[7] This dichotomy has been most recently revived as "Modernism" *v.* "Literalism." See: Michael Fried, "Art and Objecthood," *Artforum* (Summer, 1967).

occupation with time and ecology, the consciousness of *process,* is necessarily counterconservative. Permanence is revealed as being a relationship and not an attribute. Vertical structuring, based in hermetic, historically given concepts of art and its cultural role, has given way to a laterally proliferating complex of activities that are united only in their common definition as products of artistic *behavior.* This situation in art is the corollary of a general reduction in the credibility of institutions[8] and many find much recent art implicitly political. One may disagree, however, with those who would locate motivations in as doctrinaire an attitude as "Disgust with the decadence of Western civilization."[9]

Art *intended* as propaganda is almost invariably both aesthetically tedious and politically impotent. The process-oriented attitudes described here are not intentionally iconoclastic and one should be suspicious of easy comparisons with Dada. It does not follow that because some institutions have been ignored, that they are under attack. It seems rather less likely that the new work will result in the overthrow of the economy than that it will find a new relationship with it; one based, perhaps, in the assumption that art is justified as an *activity* and not merely as a means of providing supplementary evidence of pecuniary reputability. As George Brecht observed, we are used to judging a work by its suitability for the apparatus. Perhaps it is time to judge the apparatus by its suitability for the work.

The recognition of a multiplicity of times, the concentra-

[8] Robert Jay Lifton has described personal connections with experience devoid of overriding value systems and has proposed that the concept of "personality" be replaced by a more appropriate concept of "self-process." This notion of self-process is useful in understanding some recent attitudes in art: "The protean style of self-process is characterized by an interminable series of experiments and explorations—some shallow, some profound—each of which may be readily abandoned in favor of still newer psychological quests. . . . Just as protean man can readily experiment with and alter elements of his self he can also let go of, and reembrace idea systems and ideologies, all with an ease that stands in sharp contrast to the innner struggle we have in the past associated with such shifts." Robert Jay Lifton, "Protean Man," *Partisan Review* (Winter, 1968).

[9] Barbara Rose, "Problems of Criticism VI: The Politics of Art, Part III," *Artforum* (May, 1969).

tion on process and behavior, destroys the model of time as some sort of metaphysical yardstick against which the proper "length" of an activity may be measured. Works may be proposed in which materials are deployed and shifted in space in order to create compressions and rarefactions in time. Such a work would be perceived in the "extended present" within which we appreciate music. In this state of awareness the distinction between interior and exterior times, between subject and object, is eroded. There is something of Norman O. Brown's "polymorphous perverse" in the attitudes now infiltrating the hierarchical structures that have previously determined the relevance and usage of materials and media in art. It is through an indiscriminate empiricism that the new work is currently evolving.

DONALD BURGY

Space Completion Ideas

Each idea is a sequence. Discover the rule or rules of change by which the first example is related to the second. Then, based on the third example, apply that rule to draw, write, or imagine the answer for the last space.

Example 1. :

Answer:

Draw the answer on a separate paper.

Example 2. :

Up Down Left _____

Answer:

RIGHT

Write the answer on the separate paper.

The groups are numbered according to similarity of ideas.

September, 1969

1.
(hole in paper)　(sphere)　(circular orbit)　------

2.
(wafer)　(hole in paper)　(solid sphere)　-----

3.
(hole in paper)　(inside surface of sphere)　(sphere)　------

4.
(hole in paper)　(donut hole)　(donut cross section)　-----

5.
(hole in paper)　(outside surface of sphere)　(donut hole)　------

Name Idea #1

Observe something as it changes in time.
Record its names.

Observe something as it changes in scale.
Record its names.

Observe something as it changes in a hierarchy.
Record its names.

Observe something as it changes in differentiation.
Record its names.

Observe something as it changes under different emotions.
Record its names.

Observe something as it changes in different languages.
Record its names.

Observe something which never changes.
Record its names.

September, 1969

Art Idea for the Year 4000 #4

The artist designs a model of everything. The model reveals the unity of everything. Further experience of the unity reveals a level of differentiation of interrelated parts that are each rich with an infinite span of interacting entities. Revealed within each of these entities, on a second level of differentiation, is another infinite span of single entities with their unique properties, structure, behavior, and integration with the whole of this level and all other levels. This perception of both the precise view of the isolated part and the perspective of the whole operates on all entities and their apparent constancy, change in degree or kind, or simultaneity. Still further within each entity are concatenations of levels within levels differentiated to the last level containing the greatest number of infinitesimal and simple entities.

Optimum communication always occurs because model self-adaptations are responsive to uncertainties, unknowns, and the audience's capacity and need; the degree of model abstraction is always consistent with the degree of entity irreducibility on any given level; everything is revealed with the immediacy of no pre-experience; and the observer experiences everything and simultaneously experiences himself in everything.

June, 1970

IAN BURN

Consider the following individuations:

a) An ordinary mirror hanging in a room. The spectator identifies it as a mirror through his immediate recognition of its normal function.

b) The same mirror hanging in a gallery. The spectator still recognizes it as a mirror but *assumes* that the intention of the mirror is *as art*. The mirror then can be classified by either its normal function or its intentional function *as art*. However, although the art context frames the intentional function, the spectator is given no indication of any underlying concept to support such a function.

c) The same mirror hanging in a room or a gallery, displayed with notes and diagrams. This concept becomes a framework for the mirror *as art* and aims at getting the spectator's "seeing" to cohere against a particular background of inferred knowledge. The context of room or gallery no longer serves to identify the function of the mirror; the intention is built into the work.

Mirror Piece. 1967.

IAN BURN

"Xerox" Book, 1968

A blank sheet of clean white paper was copied in a Xerox 720 machine. This copy was then used to make a second copy, the second to make a third, the third to make a fourth, and so on. Each copy as it came out of the machine was reused to make the next: this was continued for one-hundred times, producing a work of one-hundred sheets. The machine was used under normal conditions and was not interfered with in any way.

IAN BURN/MEL RAMSDEN

Excerpts from The Grammarian (1970)*

I

1) It is too often blandly supposed that artwork will go on developing through changing the material or denoted subjects of its propositions while resting on a mandatory and functionally "given" framework. This entails that the formal aspects of the propositional function persist, while the properties of the propositional subject become more and more diverse. The argument here advanced is that the meta-structure of this proposition, its operation or its modality, is able to be transformed or, more simply, that specific propositions can be replaced by formative rules that lay down modes of operation.

The contention is that the formative premises through which an artwork can occur are of greater consequence than the effect of such premises (e.g., artwork may not need to be a denoted physicality and may be a study of the premises governing this denotation). It is certain that the kind of methodology that needs to be instigated in order to examine such a contention will entail shifting the general functional area of artwork into talking *about* the formation of premises rather than just operating *upon* such premises; —in other words, examining *the language* without projecting physicalities *through* the language.

If the above entails an inquiry into the nature of our artwork, it also entails some rethinking about the function of Conceptual inquiry with respect to artwork in general vis-à-vis the manner in which this artwork may be stated to be artwork.

2) The material object has provided a convenient focal-center for numerous Conceptual schemes; although this point of reference is customarily tantamount to space occupancy and mass, our first posit here is that this focal-center may be redefined and that the format of an art

* "Stating and Nominating," *VH-101*, No. 5 (May, 1971).

proposition (artwork, etc.) be considered in abstraction from what this proposition designates (i.e., its application). By translating material focal-centers into abstract place-holders we may continue by arguing that there is a radical break in mode between the abstract or propositional "grammar" of an artwork and the artwork's physical structure.

Our strategy is to maintain that this work, i.e., the arguments maintained in this paper, *not* be simplistically a member of the aggregate artwork, but rather that it be an inquiry into the mode of these arguments vis-à-vis their status as artwork. Such a strategy may hold forward some expanded notion of the function of artwork.

3) Since it is being held that an artwork may not endure contingent upon application—i.e., through nonpropositional supports—something should be said about the limits of such supports.

Application is tantamount here to the use of materials. Materials are customary for artwork but there is no basis for their being mandatory. However, if materials are used, this use per se dictates the function of the artwork. A length of rope and a six-foot steel cube, both within an art context, are different in disposition though not in function. The same goes for the profusion of operations *upon* the premises of application including (e.g.) heaps of "dirt," melting ice, (etc., etc.)—as well as the more traditional ones like permutations of shape, area, color. The essential point being that, even though the intent may not be addressed toward materials and may ostensibly be in the "realm of ideas," the function is occurring through application and is, in all instances, equivalent since it is contingent upon nonpropositional supports.

All material things are made up from states of matter. Matter, unlike material things, which are composites, is undifferentiated and diffuse, and exists in three basic states: gas, liquid, and solid. Some recent work has made use of steam, areas of liquid, and even bodies of atmosphere and, although the use of such states may alter certain assumptions about the boundaries of application, such usage is functionally no different from the conventional "mass"—i.e.,

art-object. In other words, one cannot change the function of artwork by tampering with the designated materials or internal structure of that work. A transition from a solid, which is bound internally in all directions, to (say) a gas, which has no internal boundaries, is a permutation simply in the structure and disposition of application. Such permutations are functionally straitjacketed since they are a priori contingent upon a nonpropositional (i.e., a "dumb" material) state. This is by way of stating that an allegedly singular subject, term X, is being treated rather than the proposition "this is an X."

The functional break must therefore take place outside of the permutations of application. It remains to be seen whether what has not, strictly speaking, put forward the conventional bid for membership in the aggregate of artwork can still come into an expanded notion of artwork.

4) The arguments here advanced are the result of an interest in the "grammatical" potential of artwork and how the elaboration of such a potential can cause the "break in mode" referred to in part (2). Such a break is radically distinct from "de-materialization" or from merely curtailing the contingency of the artwork on application.

Artwork is at once a formal body of terms with determinable internal relationships, and relations between those terms and objects, as well as between terms and those who produce, receive, or understand them. Some of the confusions present in the employment of many of the art terms may be at least partially overcome by carefully assessing the role of those terms that are traditionally operative within this ambit. We must, for example, decide whether the meanings of the traditional terms are derived essentially from their application. On the other hand, growing out of genuine puzzlement about this application may be a form of semiotic analysis, whose validity does not depend solely on the multi-permutations of application but on the interrelated observance of the field of connections (propositional formats, e.g., ". . . is an artwork"). This may constitute a kind of meta-art or, we could deem it, *the art of art.*

The examination of certain key terms therefore need not be seen as a pedantic interest in these terms per se: these

terms can be seen as modal analogues and, as such, critical if we are to break with the artwork's current *modus operandi,* with all its well-defined moves, roles, penalties, and rewards.

5) A coherent methodology of inquiry into the function of these arguments as an artwork must be preceded by determining some definite conceptual relationships. Since there is a word "art," many assume that there must also be a corresponding entity "art" whose ontology we can then question. The deceptive part of this reasoning lies in the fallacious question "what is this entity" and we shall take up this point later. Now, continuing the thread of our arguments, artwork is a propositional factor rather than a nonpropositional entity, so in the proposition ". . . is an artwork" we can argue that: (a) there is no mechanistic relation between such a proposition's linguistic and nonlinguistic constituents, and that (b) the linguistic term "artwork" is therefore an attribute that (c) does not require that the subject of attribution possess the characteristics of "art-ness."

Some expanded notion of artwork could be held foward by making (a), (b), and (c) exponible. Rather than trying to pin down factors in isolation, we can examine the collocation of such factors to see how they work grammatically as assertions, substantives, attributes, relations, etc.

6) This inquiry into the function of the propositional factor artwork entails that such an inquiry occur in a different status than is customary in an artwork. Certainly the seemingly natural desire to reify many of the terms of our language facilitates and is analogous to the interpretation of artwork in the sense of a material object, discrete, and static. But what of the status of an artwork outside of nonpropositional physicalities. It is no longer embedded in the supports of the physical-thing language so explicit stipulation of such a status may now come through formulating a theoretical account of the rules governing its use.

Restating, a demarcation can be made between an artwork's material supports and its propositional "grammar." This adds up to a fundamental difference in intent: the former upholds the artwork as a singular and nonproposi-

tional entity whereas the latter weds it to its function as an abstract collocation of subjects, attributes, relations, etc. It is to be observed that, although the former alleges the *application* of a concept, the latter is concerned with a concept's terminology or, more clearly, with formulating ways of *stating* this concept. (And this may ultimately prove to be the deciding factor between applied art—i.e., the construction of edifices—and Conceptual Art, i.e., a "meta-art" or a strictly abstract art.)

Application has formerly meant that artwork has maintained nonpropositional contingencies. Formulating ways of *stating* one's artwork may mean that propositional aspects such as abstract relations, predication, etc., be taken into account. So we may continue and argue that artwork is a "factor of the second order" (i.e., a semiotic factor) whose character and function proceed solely from its collocation within a proposition in which case this whole proposition may call for separate explication.

In translating the artwork from a nonpropositional application into a propositional statement, we make what is known as a "semantic ascent": a translation is made from the "material mode" to the "propositional mode." After this ascent, artwork may be largely contingent upon getting one's language straight. Consequently it may be formalizable: i.e., one of the functions of Conceptual Art may now be to sort out some basic semiotic guides or rules.

II

10)[1] There is a philosophical distinction between the grammarian and the lexicographer that may be helpful here since it exemplifies contrasting spectator capacities. The concerns of the grammarian are dependent upon making sense of the notion of significant sequence, whereas the lexicographer's task is to make sense of the notion of synonymy (e.g., between forms within the same language).

Now such a notion of synonymy entails the enumeration of constructs that are *alike* in application. Such constructs must therefore be nonpropositional since they are outside any intent except the intent to act explicitly (to take up an

[1] Parts 7, 8, and 9 have not been included.

earlier argument) as members. In the study of plants a member is that part of a plant that is considered with regard to structure and position (morphology) rather than function. This is analogous to the conventional roles of artwork, which are developed as structurals rather than as strict functionals. Synonymy evolves through changing the internal structure of members by degree; the notion of significant sequence is, on the other hand, primarily developed with regard to the function of a proposition and this is the grammarian's task. Members are nonpropositional since their function is governed by meeting and abiding by the conditions of membership. It was maintained earlier that, in *stating* artwork, it is at least prima facie a predicate. As such there is no mechanistic relation between it and any corresponding entity. In other words there's nothing mandatory about the semantics of artwork.

The credited status or subsistence of this predicate and the act of predication (i.e., the nature of the relation between what is predicated and the predicate) is an ambiguous one (particularly when there's no ontological justification for such a predication, for example, maintaining that this text is an artwork). In this respect a part of the Conceptual program may be in rigidly demarcating the manner in which these terms are related and introduced.

11) A coherent and operative framework will be contingent upon establishing certain semiotic guides or ground rules. The gap-sign in the proposition ". . . is an artwork" will tolerate an infinite number of fillers that may be broadly divided into materially contingent fillers and propositionally contingent fillers. We could take the terms "what" to exemplify the former and "why" to exemplify the latter. There's no immediate sense of modal impropriety with even the most bizzare term; still, if we make our "line of business" known, then "what is an artwork" and subsequently "what is art" are category mistakes since they are not questions but assertions that presuppose that we deal with entities.

Even though "what's" may include anything all the way from an atomic to a supergalactic scale, such spatiotemporal constituents restrict maneuvers to an ostensibly singular " . . . " But the whole format and not just single factors is

critical. Therefore a propositionally contingent filler is required, that is, one that does not introduce modally incongruous first-order entities into our line of business, which is essentially of a second-order "sense of significant sequence." The "what" is an achievement term and as such it isolates the artwork from its proposition. Previous inquiry (cf. Proceedings, text 3[2]) has maintained that the "why" can provide a genuine exit from the material mode by enabling the whole examining methodology to make a "semantic ascent" into the propositional mode. Hence the elaboration of such an ascent through the "sense of significant sequence" (i.e., syntactics, and to an extent pragmatics and semantics) may be regarded not merely as a cerebral diversion for artists, but rather as "the art of art," an exegesis of the artwork as an artwork.

12) The conditions governing nonpropositional constructs may turn out to be the bid for membership (i.e., synonymity). Our contention is that the reasons (why's) for the predication of artwork may be radically distinct from the properties of membership (what's);—that whereas members are structurals in the material mode, artwork may be stated in the propositional mode. Furthermore, questioning why this proposition functions as it does is not the same as questioning what can constitute an artwork, in other words, *what* can constitute an artwork and *why* this artwork is an artwork are questions of radically distinct intent.

Without trying to put forward quick or comprehensive retorts, we do hold it tenable that there is a distinct incompatibility between the evincing of artwork that is alike in function and the evincing of those that may be said to *be* functionals. Conventional artwork has been more concerned with the ramifications of morphological likeness than in determining the kind of relationship these constructs may have with the predicate artwork simply because of the persistent constriction of these constructs to first-order physicalities. Such constructs *cannot* be a factor within the proposition.

To restate: there's a break between the application and the stating of artwork that corresponds to the break be-

<hr>

[2] Published in *Art-Language* Vol. 1, No. 3 (1969).

tween nonpropositional and propositional constructs. The stating of artwork demands an account of the whole proposition, i.e., "this is an X," without merely zeroing in on the components of that proposition, i.e., "X." This is by way of maintaining that artwork is an artwork due to its collocation within that proposition—and Conceptual Art may fall within the sphere of indicating such collocations.

To inquire into the premises of "why an artwork is an artwork" one's methodology must first be made straight. This paper has initiated one type of inquiry in that, in continuing to use the term "artwork," we may have to provide a theoretical account of the rules for its use. It has reflected upon certain problematic features in the artwork's operation —viz. in maintaining that this present text counts as an artwork.

ROSEMARIE CASTORO

Roomcracking. 1969.

Eclipse
6:43 AM March 7, 1970

Minutes	Activity
0-6/41	From IRT local train brushing past to stop further up the depot to Grand Central Station
0-12/9	From traveling with your wife $34.76 to thirty minutes from now
0-2/52	I like mine black to whosoever is first
0-4/41	From breakfast start to the thrill is gone
0-10/13½	From fatty and sticky sweet to frere jacques
0-21/35	How do you spell frere jacques to ticket punch
0-8/29	From diminishing obelisks through graveyards to cutting through lush green vines to find the temple steps for our picnic
0-19/32	From hot wetness through a universal-like time to Stamford Connecticut
0-12/25	From gate slam to killing the cockroach in the middle of the square floor
0-12/52	From watering the trough of the inner path to history is the evidence of activity
0-0	From the reflection of the other side of the train in the near window on my left to sitting in the dining car drinking over-brewed coffee
0-20/14	From the red dot redder on the outside yellow inside orange pushing out through waiting on a slant to pass by three small windows flash green from ongoing train to stepping from one point to the other
0-12/13	From an accumulation of finite points to return to coach seat

Minutes	Activity
0-14/22	From return home through crossing a frozen pond and meeting friends to passing through to leave a note no soap radio
0-19/3	From 11:30 hurtling toward the eclipse passing piles of rusty metals through rain-spattered dusty windows to the truth is right underneath my fingernail
0-17/4	From finding the truth through searching it out by reading words and believing in signs expressing my state of being
6/48	From teeth gritting relax to return frozen marshes uncrossed ponds holding on to time I'm the philosopher you are the navigator where is the place yet to come?
0-7/10	From on going that's where irrevocably irrepressibly irretrievably
0-7/31	From 12:20 bringing it to them don't let them in yet we are gathering it all together we may just thrust it out the door and close it fast Goethe's girlfriend was not Mephistopheles Dante had Beatrice but who did Goethe have?
0-13	From 12:30 PM cloud darkening snow patched forest to why bother crossing ponds? It's all on your side anyway. Hey you with your head in the trunk of your car. Would you pay me to take another train trip to Boston?
0-1/6	From dumping ground to arrival in Boston
0-29/35	From ektachrome slides snatches of color through the darkness of the station under ground

Minutes	Activity
0-74/25	Boston Commons six cards three maidens destroyed house fake green grass carpet covered with marble dust visitors sitting in listening to the birds Poussin a dog checking in to anywhere Bosch Bayeux tapestry the point of my pen 1:30 PM the only straight man was a negro with white hair the truth is in those letters be warm my love to 167 Newberry Street to register my explosion
0-	From the registered explosion to 5:00 PM
0-5/33	From 5:00 o'clock in the afternoon at 6 Melrose to what do I have what do I want what do I need I have all I want to do is read

Rosemarie Castoro

Roger Cutforth

THE

EMPIRE STATE BUILDING

A Reference Work

1969

The History of a Landmark

The Thompson Farm.

The Astor Mansion

The Waldorf-Astoria Hotel. (Demolished 1929)

The Empire State Building. (Completed 1931)

How the Empire State Building Was Constructed

Conception. The highest building in the world.

Conceiving the basic plans.

1 of 16 concepts.

The solution of the structure.

The base of 5 stories.

The tower of 81 stories.

The pointed top terminating the

building at the 102nd storey.*

Construction. (1)

Foundations, 55 feet.

Steel columns embedded in bedrock.

Steel framework of the building.

Exterior walls, Indiana limestone.

Exterior fittings, aluminum and

chrome-nickel.

Construction. (2)

Begun March 1930.

Completed May 1931.

*Added to this latter a 22 storey TV tower.

The World's Tallest Structure

1931. The Empire State Building.

The Men

The Architects. Shreve, Lamb & Harmon Associates.

The Builders.

The Manufacturers.

The Empire State Building at Night

The upper 30 floors and tower illuminated by

floodlights from dusk until midnight.

Hub of Midtown Manhattan

The centre of a Transportation Network, only

minutes from the following transit hubs:

East Side Airways Terminal.

West Side Airways Terminal.

Grand Central Station.

Pennsylvania Station.

Port Authority Trans Hudson Bus Terminal.

New York Bus and Subway Systems.

Television Tower:

Transmitting centre of all TV stations in

the metropolitan area.

The View From The Empire State Building Observatories

North. New York City Public Library, Rockefeller

Center, Times Square, Central Park, The

George Washington Bridge, Borough of

the Bronx.

South. Wall Street, The Woolworth Building,

Flatiron Building, Brooklyn Bridge,

Borough of Brooklyn.

East. The Chrysler Building, United Nations

Building, The East River, Queensboro

Bridge, Borough of Queens.

West. Macy's, Madison Square Garden,

New York Harbor, The Hudson River,

New Jersey.

The World's Most Distinguished Address

The Empire State Building,

New York 1, New York.

The Eight Wonders of the World

The Great Pyramids.

The Hanging Gardens of Babylon.

The Statue of Zeus.

The Temple of Diana.

The Tomb of King Mausolus.

The Colossus of Rhodes.

The Lighthouse of Pharos.

The Empire State Building.

A Visit to the Eighth Wonder of the World

The Entrance.

The Lobby.

The Elevators.

The 86th Floor Observatory, 1050 feet above

street level.

The 102nd Floor Observatory, 1250 feet above

street level.

On May 9 (friday), May 12 (monday) and May 30 (friday) 1969 at 3:00 Greenwich Mean Time (9:00 EST) Jan Dibbets will make the gesture indicated on the overside at the place marked "X" in Amsterdam, Holland.

Le 9 May (vendredi), le 12 May (lundi), le 30 May (vendredi) 1969 à 3:00 heures di l'après-midi GMT, Jan Dibbets fera le geste comme indiqué à ce verso à l'endroit marqué "X" à Amsterdam, Pays Bas.

Am 9 Mai (Freitag), 12 Mai (Montag) und 30 Mai (Freitag) 1969 um 3:00 Nachmittags (GMT), Jan Dibbets wird das Gebarde wie am anderen Seite machen auf der mit einem "X" bezeichneten Stelle in Amsterdam, Holland.

Op 9 mei (vrijdag), 12 mei (maandag) en 30 mei (vrijdag) 1969 om 3:00 uur 's middags (GMT), zal Jan Dibbets het gebaar, zoals op de andere kant van deze kaart, maken op de met een "X" gemarkeerde plek in Amsterdam, Nederland.

SETH SIEGELAUB NEW YORK

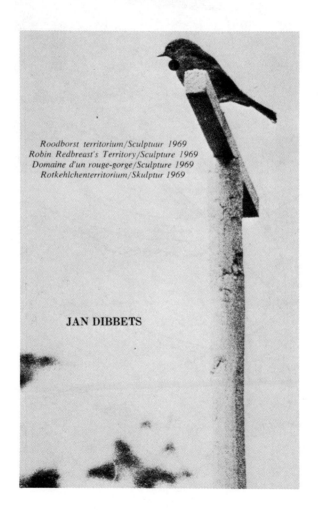

Roodborst territorium/Sculptuur 1969
Robin Redbreast's Territory/Sculpture 1969
Domaine d'un rouge-gorge/Sculpture 1969
Rotkehlchenterritorium/Skulptur 1969

JAN DIBBETS

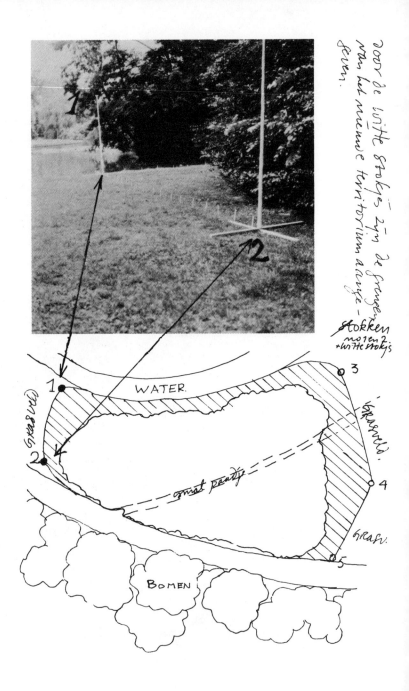

voor de witte stokjes zijn de pingen
van het nieuwe territorium aange-
geven.

stokken
noten?
+witte stokjes

WATER.

GRASVELD

1

2

3

omat paadje

grasveld.

4

GRASV.

5

BOMEN

Jan Dibbets: *Robin Redbreast's Territory*. 1969.

"I think it's quite a good thing to do, but it's stupid for other people to do it, or to buy it from me. What matters is the feeling. I discovered it's a great feeling to pick out a point on the map and to search for the place for three days, and then to find there are only two trees standing there, and a dog pissing against the tree. But someone who tried to buy that from you would be really stupid, because the work of art is the feeling, and he couldn't buy that from me, . . .

. .
"I must say I don't see how to sell these kinds of ideas. If someone can use them he can take them. Selling is not a part of art.

. .
"I really believe in having projects which in fact can't be carried out, or which are so simple that anyone could work them out. I once made four spots on the map of Holland, without knowing where they were. Then I found out how to get there and went to the place and took a snapshot. Quite stupid. Anybody can do that."

Jan Dibbets: *Perspective Correction.* 1969.

Boolean Image, excerpts from *The Boolean Package.* 1969.

CARL FERNBACH-FLARSHEIM

The Boolean Image, Conceptual Typewriter. 1970.

THE MORTAL

possibility B:
one-directional activity

possibility A:
two-directional activity

early development

I react to structured stimuli

convergently

I plan sense
I search
I construct
I destroy
I understand

I react to unstructured stimuli

convergently

I judge
I pair
I count
I repress

I react to structured stimuli

convergently

I plan sense
I search
I construct
I destroy
I understand

I react to unstructured stimuli

divergently

I play random
I sit
I dabble
I am indifferent

Carl Fernbach-Flarsheim: Excerpts from *The Conceptual Cloud,* Game Book 1. 1967.

middle development

late development

progress route

I achieve a measure of self-realisation through mental and physical exercises.

All warning signals for my survival are left under control of my own body and mind.

I successfully fuse inner and outer environment by achieving total control over the consciousness; I represent immortality.

I enlarge control over my environment technologically.

My weapons become more deadly, my armour more efficient. I may end here.

I gain complete control over my environment including my evolution. Warning signals inside body and mind are eliminated for greatest comfort. This may result in a semiotic fusion of robot and human brain: Warning signals located inside robot. Or my survival may be put exclusively in hands of robot.

The robot represents my immortality.

THE IMMORTAL

DAN GRAHAM

```
1,000,000,000,000,000,000,000,000.00000000 miles to edge of known universe
    100,000,000,000,000,000,000.00000000 miles to edge of galaxy (Milky Way)
            3,573,000,000.00000000 miles to edge of solar system (Pluto)
                    205.00034600 miles to Washington, D. C.
                      2.85100000 miles to Times Square, New York, N. Y.
                       .38600000 mile  to Union Square subway stop
                       .11820000 mile  to corner 14thSt. and First Ave.
                       .00367000 mile  to front door, Apart. 1D, 153 First Ave.
                       .00021600 mile  to typewriter paper page
                       .00000700 mile  to lens of glasses
                       .00000098 mile  to cornea from retinal wall
```

March 31, 1966

	Anoxemia (Appetite loss)	Blood clot	Blurring of vision	Constipation	Convulsion	Decreased libido	Dermatosis	Depression, torpor	Headache	Hepatic disfunction	Hypertension	Insomnia	Nasal congestion	Nausea, vomiting	Pallor
STIMULANT also **APPETITE DEPRESSANT**															
Dextroamphetamine (Dexedrine)	●			●	●				●			●	●	●	
Methamphetamine chloride (Desoxyn)	●			●	●				●			●	●	●	
ANTI-DEPRESSANT															
Iproniazid				●					●	●	●				
Trofanil			●				●		●		●				
TRANQUILIZER															
Chlorpromazine				●		●	●	●	●						●
Hydroxyzine				●			●	●	●					●	●
Meprobamate					●			●				●			
Promazine		●					●	●	●						
Resperpine	●				●	●	●	●				●	●		
Thiopropazate			●	●	●		●	●	●	●		●		●	
SEDATIVE															
Barbitol			●					●						●	
Phenobarbitol			●					●						●	
ANTI-MOTION SICKNESS															
Dimenhydrinate (Dramamine)								●	●					●	
Marezine								●	●						
Meclizine								●	●					●	
CONTRACEPTIVE															
Norethynodrel (Enovid)		●	●						●	●				●	●

127

Schema for a set of poems whose component pages are specifically published as individual poems in various magazines and collections. Each poem-page is intended to be set in its final form by the editor of the publication where it is to appear, the exact data used to correspond in each particular instance to the fact(s) of its published appearance. The following schema is entirely arbitrary; any might have been used, and deletions, additions or modifications for space or appearance on the part of the editor are possible.

Schema:

(Number of)	adjectives
(Number of)	adverbs
(Percentage of)	area not occupied by type
(Percentage of)	area occupied by type
(Number of)	columns
(Number of)	conjunctions
(Depth of)	depression of type into surface of page
(Number of)	gerunds
(Number of)	infinitives
(Number of)	letters of alphabets
(Number of)	lines
(Number of)	mathematical symbols
(Number of)	nouns
(Number of)	numbers
(Number of)	participles
(Perimeter of)	page
(Weight of)	paper sheet
(Type)	paper stock
(Thinness of)	paper stock
(Number of)	prepositions
(Number of)	pronouns
(Number of point)	size type
(Name of)	typeface
(Number of)	words
(Number of)	words capitalized
(Number of)	words italicized
(Number of)	words not capitalized
(Number of)	words not italicized

This schema was conceived in March, 1966.

Using this or any arbitrary schema produces a large, finite permutation of specific, discrete poems.

1	adjectives
3	adverbs
1192½ sq. ems	area not occupied by type
337½ sq. ems	area occupied by type
1	columns
0	conjunctions
nil	depression of type into surface of page
0	gerunds
0	infinitives
363	letters of alphabet
27	lines
2	mathematical symbols
38	nouns
52	numbers
0	participles
8½ x 5	page
17½ x 22½	paper sheet
offset cartridge	paper stock
5	prepositions
0	pronouns
10 pt.	size type
Press Roman	typeface
59	words
2	words capitalized
0	words italicized
57	words not capitalized
59	words not italicized

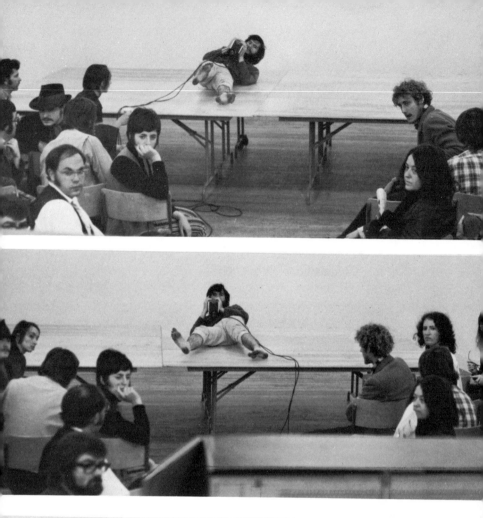
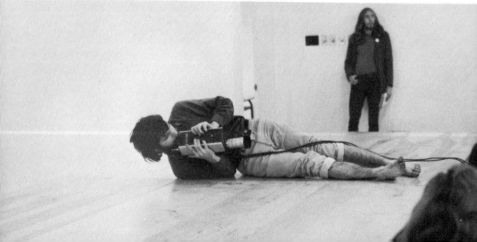

DAN GRAHAM

TV Camera/Monitor Performance, 1970

A stage facing and at the level of the tops of heads of members of a seated audience as wide, but approximately ten rows deep, is opposite and parallel to a rear TV monitor placed just above the heads of those in the last row. Lying, feet facing the audience, on my back I roll parallel to the left and right edges of the stage while directing a TV camera extending an image to the monitor. My "orientation" consists of slowly and continuously rolling while at all times possible orienting the camera to feed back the image to the monitor simultaneously.

The monitor's image shows images within image-reflecting machine feedback; my legs—body extensions—shifting in realignment to the direction of the monitor; the heads of the spectators turning either one way or the other. These all are closed feedback systems or loops (the audience to its own bodies, my "learning"/machine to itself, and the machine in terms of itself). The audience shifts attention as they and the performer shift the tensions of their muscular framework.

HANS HAACKE

Statements

A blanket of snow may be used like paper or canvas on which marks and traces can be made. Snow also lends itself as inexpensive, although ephemeral, construction material for shape-oriented sculpture. Neither approach goes essentially beyond what is traditionally conceived of as painting or sculpture.

Another attitude, however, would be to consider snow as part of a large meteorological system determined by humidity, temperature, air pressure, velocity, and direction of winds as well as topographical characteristics of the earth. All of these factors are interrelated and affect each other. Taking such an attitude would lead to working strategies that could expose the functioning and the consequences of these interdependent processes.

For a formalist the resulting situations might appear as just another black-and-white drawing or three-dimensional composition to be judged according to standard rules of formal accomplishment. However, formal criteria bypass the systems concept and are therefore irrelevant.

New York City, February, 1969

LOCAL CLIMATOLOGICAL DATA

U.S. DEPARTMENT OF COMMERCE - C. R. SMITH, Secretary

ENVIRONMENTAL SCIENCE SERVICES ADMINISTRATION -- ENVIRONMENTAL DATA SERVICE

NEW YORK METEOROLOGICAL OBS.
CENTRAL PARK
DECEMBER 1968

Latitude 40° 47' N Longitude 73° 58' W Elevation (ground) 132 ft. Standard time used: EASTERN

Date	Temperature (°F)						Weather types shown by code 1-9 on dates of occurrence	Snow, Sleet, or Ice on ground at 07AM (In.)	Precipitation		Avg station pressure (In.) Elev. 47 feet m.s.l	Wind						Sunshine		Sky cover (Tenths)			Date
	Maximum	Minimum	Average	Departure from normal	Average dew point	Degree days (Base 65°)			Total (Water equivalent) (In.)	Snow, sleet (In.)		Resultant direction	Resultant speed (m.p.h.)	Average speed (m.p.h.)	Fastest mile Speed (m.p.h.)	Fastest mile Direction	Total (Hours and tenths)	Percent of possible	Sunrise to sunset	Midnight to midnight			
1	2	3	4	5	6	7	8	9	10	11	12	13	14	15	16	17	18	19	20	21	22		
1	47	32	40	-1	27	25		0	.07	0	30.27	14	2.5	6.0	12	S	4.8	50	2	1			
2	60	47	54	14	44	11		0	.23	0	29.67	22	8.4	7.9	13	SW	7.8	82	2				
3	54	43	50	10	34	15		0	T	0	29.94	22	3.0	5.9	15	E	6.6	70	3				
4	57	43	51	11	46	14		0	1.78	0	29.32	09	5.4	11.9	29	E	0.0	0	4				
5	45	34	40	1	24	25		0	T	0	29.28	23	15.1	16.1	33	N	5.0	53	5				
6	39	32	36	-3	13	29		0	0	0	29.77	26	12.8	13.5	28	N	9.4	100	6				
7	40	30	35	-3	16	30		0	0	0	29.93	28	7.1	8.2	19	NW	9.4	100	7				
8	38	26	31	-7	15	34		0	0	0	29.85	34	12.2	12.5	25	NW	7.4	83	8				
9	27	13	20	-17	2	45		0	0	0	30.07	32	14.2	16.3	38	NW	9.4	100	9				
10	24	9	17	-20	-8	48		0	0	0	30.36	33	12.1	12.8	22	NW	9.3	100	10				
11	34	15	25	-12	10	40		0	0	0	30.42	30	2.2	4.9	12	NE	7.2	77	11				
12	41	29	35	-1	14	30		0	0	0	30.19	24	6.2	6.8	17	S	9.3	100	12				
13	60	36	48	12	30	17		T	0	0	30.02	24	9.1	9.8	17	SW	9.3	100	13				
14	56	34	45	9	42	20		0	.31	0	29.72	33	4.7	7.2	22	N	0.0	0	14				
15	34	19	27	-9	18	33		0	.47	5.2	29.34	32	14.6	15.0	27	NW	3.6	39	15				
16	29	17	23	-12	9	42		5	0	0	29.51	26	11.1	11.8	24	NW	7.3	79	16				
17	39	28	34	-1	12	31		4	0	0	29.75	27	10.4	11.2	18	N	9.3	100	17				
18	38	28	33	-2	17	32		0	0	0	30.01	23	6.8	7.2	14	NW	9.3	100	18				
19	38	35	37	2	28	28		T	0	0	29.89	07	3.1	5.5	13	NW	0.9	10	19				
20	34	30	32	-3	31	25		T	0	0	29.60	28	6.3	7.6	23	NW	1.4	15	20				
21	40	33	37	2	23	28		T	0	0	30.02	32	8.9	9.9	21	NW	1.8	19	21				
22	37	32	35	1	24	30		T	.29	0	30.11	04	3.1	4.6	9	NE	0.4	4	22				
23	49	32	41	7	34	24		0	.39	0	29.40	26	6.2	10.1	23	N	2.3	25	23				
24	34	23	29	-5	12	36		0	T	0	29.51	29	14.1	15.5	29	NW	7.4	79	24				
25	23	13	18	-16	-5	47		0	0	0	29.88	34	18.5	16.5	31	NW	9.3	100	25				
26	32	11	17	-17	4	48		0	0	0	30.20	31	9.8	10.2	17	NW	9.3	100	26				
27	28	21	25	-9	14	40		0	.12	1.8	30.06	03	1.8	5.2	11	NE	0.0	0	27				
28	50	28	42	8	36	23		0	.14	0	29.38	09	3.9	7.8	20	S	0.0	0	28				
29	47	28	38	4	20	27		0	0	0	29.50	28	12.5	12.9	25	NW	5.8	62	29				
30	30	25	31	-3	13	34		0	0	0	30.16	33	6.9	9.2	18	NW	9.3	100	30				
31	-2	31	37		23	28		0	.15	0	30.07	21	3.2	5.8	10	S	3.1	33	31				

| | Sum 1258 | Sum 865 | | | | Total 944 | Dep -42 | | Total 4.15 | Total 7.0 | 29.85 | 29 | 5.7 | 9.9 | 38 | NW | 175.8 | | Sum | Sum |
| Avg | +5.8 | 27.9 | Avg 34.3 | -1.6 | Avg 20 | Season to date Total 1668 | Dep -37 | Number of days | Dep | Dep 0.89 | | Date 09 | | | Possible 286.8 | month 61 | | | Avg | Avg |

• Extreme for the month. May be the last of more than one occurrence.
T In columns 9, 10, and 11 and in the Hourly Precipitation table indicates an amount too small to measure.
X Heavy fog — visibility ¼ mile or less.

Greatest in 24 hours and dates
Precipitation 1.78 4
Snow, Sleet 5.2 15

Greatest depth on ground of snow, sleet or ice and date 5 15+

HOURLY PRECIPITATION (Liquid in Inches)

Date	A. M. Hour ending at												P. M. Hour ending at												Date	
	1	2	3	4	5	6	7	8	9	10	11	12	1	2	3	4	5	6	7	8	9	10	11	12		
2	.05	.06	.06	.04	.01	.01	T															.05	.02		2	
3																							T		3	
4	T	.01	.01	.01	.06	.14	.11	.16	.15	.27	.22	.20	.04	.04	.15	.08	.08	.04	T	T	.01				4	
14							T	T	.03	.02	.01	.01	T	.01	.10	.06	.05	.01	.04	.01	T	.01	.05	.07	.03	14
15	.03	.05	.07	.10	.07	.05	.02	.02	.03	T	T	.03	T													15
22															T	T					.02	.03	.08	.05	.11	22
23	.11	.07	.06	.07	.07	.01	T																T		23	
27	T	.01	T	T		.01	T					T	.01	.03	.01	.01	.04	.02	T			.09	T		27	
31																				.01	.02	.04	.04	.04	T	31

Data in columns 6, 12, 13, 14, and 15 are based on 8 observations per day at 3-hour intervals. Wind directions are those from which the wind blows. Resultant wind is the vector sum of wind directions and speeds divided by the number of observations. Figures for directions are tens of degrees from true North; i.e., 09 = East, 18 = South, 27 = West, 36 = North, and 00 = Calm. When directions are in tens of degrees in Col. 17, entries in Col. 16 are fastest observed 1-minute speeds. If the / appears in Col. 17, speeds are gusts. Any errors detected will be corrected and changes in summary data will be annotated in the annual Summary if published.

AVERAGES BY HOURS

Hour (Local Time)	Station pressure	Dry bulb	Wet bulb	Dew point	Relative humidity	Wind speed	Wind direction	Resultant wind
01	29.85	33	29	60	20	9.5	30	6.2
04	29.45	32	28	61	19	9.4	30	5.3
07	29.87	32	28	61	19	8.8	29	4.9
10	29.90	33	29	58	19	10.1	29	6.2
13	29.83	37	31	52	20	10.5	29	6.7
16	29.83	37	32	53	20	10.4	29	5.7
19	29.86	35	30	57	20	10.2	29	4.9
22	29.94	34	30	60	21	10.0	29	6.2

USCOMM ESSA ASHEVILLE 1950

Subscription Price: Local Climatological Data $1.00 per year including annual Summary if published. Single copy 10 cents for monthly Summary; 15 cents for annual Summary. Checks or money orders should be made payable and remittances and correspondence should be sent to the Superintendent of Documents, U.S. Government Printing Office, Washington, D.C. 20402.

I certify that this is an official publication of the Environmental Science Services Administration, and is compiled from records on file at the National Weather Records Center, Asheville, North Carolina.

William H. Haggard
Director, National Weather Records Center

Record and Complementary Record of
"Wind in Water: Snow." 1969.

133

Question:

Would the fact that Governor Rockefeller
has not denounced President Nixon's
Indochina policy be a reason for you not
to vote for him in November ?

Answer:

If 'yes'
please cast your ballot into the left box;
if 'no'
into the right box.

Hans Haacke: *Proposal: Poll of MOMA Visitors.* 1970.

Hans Haacke: *Communication System—UPI.* 1969.

TOP ROW THE ENDS OF EIGHT 1" INCH LINES POSITIONED AT 90° TO THE PICTURE PLAN
2ND ROW EIGHT 1" LINES POSITIONED AT 30° TO THE PICTURE PLANE
3RD ROW EIGHT 1" LINES POSITIONED AT 60° TO THE PICTURE PLANE
BOTTOM ROW EIGHT 1" LINES POSITIONED ON THE SURFACE OF THE PICTURE PLANE

Untitled. 1968. Drawing.

DOUGLAS HUEBLER

The world is full of objects, more or less interesting; I do not wish to add any more.

I prefer, simply, to state the existence of things in terms of time and/or place.

More specifically, the work concerns itself with things whose interrelationship is beyond direct perceptual experience.

Because the work is beyond direct perceptual experience, awareness of the work depends on a system of documentation.

This documentation takes the form of photographs, maps, drawings, and descriptive language.[1]

What I say is part of the artwork. I don't look to critics to say things about my work. I tell them what it's about.

People deny words have anything to do with art. I don't accept that. They do. Art is a source of information.[2]

My work is concerned with determining the form of art when the role traditionally played by visual experience is mitigated or eliminated. In a number of works I have done so by first bringing "appearance" into the foreground of the piece and then suspending the visual experience of it by having it actually function as a document that exists to serve as a structural part of a conceptual system. The systems used are random or logical sets of numbers, aspects of time, or propositions in language; the documents of "appearance" are photographs that have been made with the camera used as a duplicating device whose operator makes no "aesthetic" decisions.

Whatever is visual in the work then exists arbitrarily and its real existence remains as itself—in life along with everything else—separate from art and the purposes of art.[3]

[1] From catalogue statement, *January 5–31, 1969,* Seth Siegelaub, New York City.

[2] From *"Thinkworks,"* by David Shirey in *Art in America* (May–June, 1969).

[3] From an independent statement.

Douglas Huebler: *Duration Piece #15.* 1969.

Global

Beginning on January 1, 1970 a reward of $1,100 will be paid to the person who provides the information resulting in the arrest and conviction of Edmund Kite McIntyre wanted by the Federal Bureau of Investigation for Bank Robbery (Title 18, U.S. Code, Sections 2113a and 2113d). On February 1, 1970 $100.00 will be reduced from that first offer making it $1,000.00; it will be reduced another $100.00 on the first day of each subsequent month until there will exist no reward at all on January 1, 1971.

I, (Douglas Huebler), guarantee (by my signature below) the full payment of the reward offered above. In the event that this piece has been purchased from me at any time between September 1969 and January 1971 its new owner will have assumed responsibility for payment of any reward that is claimed.

(The price for this piece is $1,100.00: from that sum I will reimburse its owner any money that he pays as a reward in completing the destiny of its design.)

This statement and the "Wanted" publication (FBI No. 342,327F) will constitute the finished form of this piece on January 1, 1971 unless Mr. McIntyre is apprehended and convicted in which case copies of all attendant documents concerning his conviction will join altogether to form the piece.

Location Piece #14
Global
Proposal*

During a given 24 hour period 24 photographs will be made of an imagined

point in space that is directly over each of 24 geographic locations that exist as a

series of points 15 longitudinal degrees apart along the 45^O Parallel North of the

Equator.

The first photograph will be made at 12:00 Noon at 0^O Longitude near Coutras,

France. The next, and each succeeding photograph, will be made at 12:00 Noon as

the series continues on to 15^O Longitude East of Greenwich (near Senj, Yugoslavia)...

on to 30^O, 45^O, 60^O, etc., until completed at 15^O Longitude West of Greenwich.

"Time" is defined in relationship to the rotation of the Earth around its axis and

as that rotation takes 24 hours to be completed each "change" of time occurs at each

15^O of longitude (Meridian); the same virtual space will exist at "Noon" over each

location described by the series set for this piece. The 24 photographs will

document the same natural phenomenon but the points from which they will be made

graphically describe 8,800 miles of linear distance and "fix" 24 hours of sequential

time at one instant in real time.

The 24 photographs, a map of the world and this statement will join altogether

to constitute the form of this piece.

* The owner of this work will assume the responsibility for fulfilling every

aspect of its physical execution.

July, 1969 Douglas Huebler

Douglas Huebler: *Location Piece #14.* "Model" photograph. 1969.

STEPHEN JAMES KALTENBACH

Lip Stamp

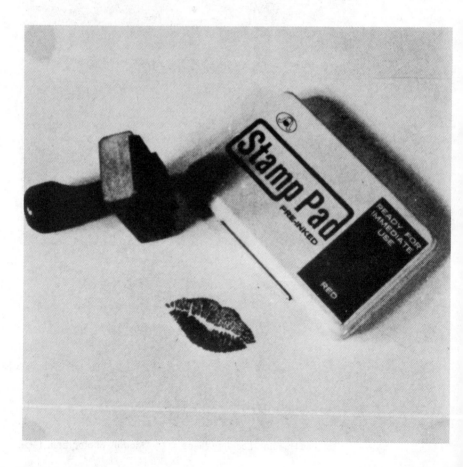

Lip Stamp.

EXPOSE YOUR TIES

"I got the idea of altering the subway posters by using what existed and extending it. My lip stamp was especially intended for one poster. It was a Fruit of the Loom stocking poster, which displayed a pretty chick with a very short dress and nice legs. Right up high on her thigh was a stamp that said "Fruit of the Loom." So when I rode the subways I carried the stamp in my pocket and whenever I'd come on one of those posters, I'd put my stamp right beside it."

ON KAWARA

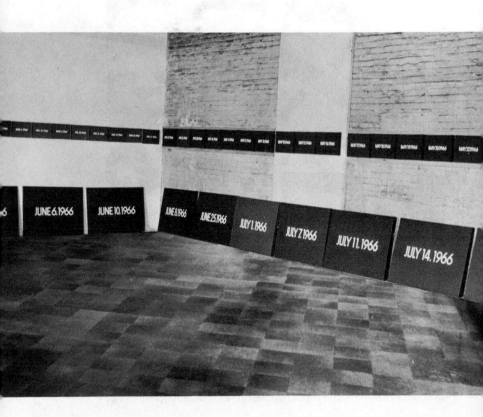

Eight quintillion eight hundred two quadrillion -
fifty-seven trillion two hundred one billion eight
hundred fifty million five hundred four thousand -
one hundred and eight ten quintillionths two hun-
dred five trillion six billion seven hundred twelve
million nine hundred ninety-five thousand one hun-
dred eighty

↑ *Code: Eight Quintillion.* 1969.

Today, Environment in the Artist's Studio. 1966.

NOV 25 1970

I GOT UP AT
8.03 A.M.

On Kawara
1-4-6 Tamagawacho
Setagaya-ku,
Tokyo, Japan

URSULA MEYER
26 RIVERSIDE
DRIVE
NEW YORK N.Y.
10025 U.S.A.

AIR MAIL

I GOT UP AT
8.25 A.M.

On Kawara
1-4-6 Tamagawacho
Setagaya-ku,
Tokyo, Japan

URSULA MEYER
26 RIVERSIDE
DRIVE
NEW YORK N.Y.
10025 U.S.A.

AIR MAIL

POST CARD

Elevated expressways radiate into beautiful geometrical
patterns as they cross in downtown Tokyo. In the
distance is the 36-story Kasumigaseki Building.

NOV 28 1970

I GOT UP AT
8.01 A.M.

On Kawara
1-4-6 Tamagawacho
Setagaya-ku,
Tokyo, Japan

URSULA MEYER
26 RIVERSIDE
DRIVE
NEW YORK N.Y.
10025 U.S.A.

AIR MAIL

POST CARD

Nishi-Ginza—The Super-Express-Train of the New
Tokaido Line gliding through the serene morning
stillness near Nishi-Ginza.
©Nishi-Ginza ©Barrio de Nishi-Ginza

NOV 27 1970

I GOT UP AT
8.34 A.M.

On Kawara
1-4-6 Tamagawacho
Setagaya-ku,
Tokyo, Japan

URSULA MEYER
26 RIVERSIDE
DRIVE
NEW YORK N.Y.
10025 U.S.A.

AIR MAIL

On Kawara: *I Got Up.* 1970.

249491 BC 249481 BC 249471 BC 249461 BC 249451 BC 249441 BC 249431 BC 249421 BC 249411 BC 249401 BC 249391 BC 249381 BC 249371 BC 249361 BC 249351 BC 249341 BC 249331 BC 249321 BC 249311 BC 249301 BC 249291 BC 249281 BC 249271 BC 249261 BC 249251 BC 249241 BC 249231 BC 249221 BC 249211 BC

249492 BC 249482 BC 249472 BC 249462 BC 249452 BC 249442 BC 249432 BC 249422 BC 249412 BC 249402 BC 249392 BC 249382 BC 249372 BC 249362 BC 249352 BC 249342 BC 249332 BC 249322 BC 249312 BC 249302 BC 249292 BC 249282 BC 249272 BC 249262 BC 249252 BC 249242 BC 249232 BC 249222 BC 249212 BC

249493 BC 249483 BC 249473 BC 249463 BC 249453 BC 249443 BC 249433 BC 249423 BC 249413 BC 249403 BC 249393 BC 249383 BC 249373 BC 249363 BC 249353 BC 249343 BC 249333 BC 249323 BC 249313 BC 249303 BC 249293 BC 249283 BC 249273 BC 249263 BC 249253 BC 249243 BC 249233 BC 249223 BC 249213 BC

249494 BC 249484 BC 249474 BC 249464 BC 249454 BC 249444 BC 249434 BC 249424 BC 249414 BC 249404 BC 249394 BC 249384 BC 249374 BC 249364 BC 249354 BC 249344 BC 249334 BC 249324 BC 249314 BC 249304 BC 249294 BC 249284 BC 249274 BC 249264 BC 249254 BC 249244 BC 249234 BC 249224 BC 249214 BC

249495 BC 249485 BC 249475 BC 249465 BC 249455 BC 249445 BC 249435 BC 249425 BC 249415 BC 249405 BC 249395 BC 249385 BC 249375 BC 249365 BC 249355 BC 249345 BC 249335 BC 249325 BC 249315 BC 249305 BC 249295 BC 249285 BC 249275 BC 249265 BC 249255 BC 249245 BC 249235 BC 249225 BC 249215 BC

249496 BC 249486 BC 249476 BC 249466 BC 249456 BC 249446 BC 249436 BC 249426 BC 249416 BC 249406 BC 249396 BC 249386 BC 249376 BC 249366 BC 249356 BC 249346 BC 249336 BC 249326 BC 249316 BC 249306 BC 249296 BC 249286 BC 249276 BC 249266 BC 249256 BC 249246 BC 249236 BC 249226 BC 249216 BC

249497 BC 249487 BC 249477 BC 249467 BC 249457 BC 249447 BC 249437 BC 249427 BC 249417 BC 249407 BC 249397 BC 249387 BC 249377 BC 249367 BC 249357 BC 249347 BC 249337 BC 249327 BC 249317 BC 249307 BC 249297 BC 249287 BC 249277 BC 249267 BC 249257 BC 249247 BC 249237 BC 249227 BC 249217 BC

249498 BC 249488 BC 249478 BC 249468 BC 249458 BC 249448 BC 249438 BC 249428 BC 249418 BC 249408 BC 249398 BC 249388 BC 249378 BC 249368 BC 249358 BC 249348 BC 249338 BC 249328 BC 249318 BC 249308 BC 249298 BC 249288 BC 249278 BC 249268 BC 249258 BC 249248 BC 249238 BC 249228 BC 249218 BC

249499 BC 249489 BC 249479 BC 249469 BC 249459 BC 249449 BC 249439 BC 249429 BC 249419 BC 249409 BC 249399 BC 249389 BC 249379 BC 249369 BC 249359 BC 249349 BC 249339 BC 249329 BC 249319 BC 249309 BC 249299 BC 249289 BC 249279 BC 249269 BC 249259 BC 249249 BC 249239 BC 249229 BC 249219 BC

249500 BC 249490 BC 249480 BC 249470 BC 249460 BC 249450 BC 249440 BC 249430 BC 249420 BC 249410 BC 249400 BC 249390 BC 249380 BC 249370 BC 249360 BC 249350 BC 249340 BC 249330 BC 249320 BC 249310 BC 249300 BC 249290 BC 249280 BC 249270 BC 249260 BC 249250 BC 249240 BC 249230 BC 249220 BC

249190 BC 249189 BC 249188 BC 249187 BC 249186 BC 249185 BC 249184 BC 249183 BC 249182 BC 249181 BC
249180 BC 249179 BC 249178 BC 249177 BC 249176 BC 249175 BC 249174 BC 249173 BC 249172 BC 249171 BC
249170 BC 249169 BC 249168 BC 249167 BC 249166 BC 249165 BC 249164 BC 249163 BC 249162 BC 249161 BC
249160 BC 249159 BC 249158 BC 249157 BC 249156 BC 249155 BC 249154 BC 249153 BC 249152 BC 249151 BC
249150 BC 249149 BC 249148 BC 249147 BC 249146 BC 249145 BC 249144 BC 249143 BC 249142 BC 249141 BC
249140 BC 249139 BC 249138 BC 249137 BC 249136 BC 249135 BC 249134 BC 249133 BC 249132 BC 249131 BC
249130 BC 249129 BC 249128 BC 249127 BC 249126 BC 249125 BC 249124 BC 249123 BC 249122 BC 249121 BC
249120 BC 249119 BC 249118 BC 249117 BC 249116 BC 249115 BC 249114 BC 249113 BC 249112 BC 249111 BC
249110 BC 249109 BC 249108 BC 249107 BC 249106 BC 249105 BC 249104 BC 249103 BC 249102 BC 249101 BC

249100 BC 249099 BC 249098 BC 249097 BC 249098 BC 249095 BC 249094 BC 249093 BC 249092 BC 249091 BC
249090 BC 249089 BC 249088 BC 249087 BC 249086 BC 249085 BC 249084 BC 249083 BC 249082 BC 249081 BC
249080 BC 249079 BC 249078 BC 249077 BC 249076 BC 249075 BC 249074 BC 249073 BC 249072 BC 249071 BC
249070 BC 249069 BC 249068 BC 249067 BC 249066 BC 249065 BC 249064 BC 249063 BC 249062 BC 249061 BC
249060 BC 249059 BC 249058 BC 249057 BC 249056 BC 249055 BC 249054 BC 249053 BC 249052 BC 249051 BC
249050 BC 249049 BC 249048 BC 249047 BC 249046 BC 249045 BC 249044 BC 249043 BC 249042 BC 249041 BC
249040 BC 249039 BC 249038 BC 249037 BC 249036 BC 249035 BC 249034 BC 249033 BC 249032 BC 249031 BC
249030 BC 249029 BC 249028 BC 249027 BC 249026 BC 249025 BC 249024 BC 249023 BC 249022 BC 249021 BC
249020 BC 249019 BC 249018 BC 249017 BC 249016 BC 249015 BC 249014 BC 249013 BC 249012 BC 249011 BC
249010 BC 249009 BC 249008 BC 249007 BC 249006 BC 249005 BC 249004 BC 249003 BC 249002 BC 249001 BC

On Kawara: *One Million Years*. 1970. Page 1497.

20. — *Ecole ou (et) époque préférées selon les catégories socio-professionnelles.*

	S. R.₁	Renaissance italienne	Hollandais et Flamands	Espagnols	Français et Italiens des XVIIᵉ et XVIIIᵉ s.	Français XIXᵉ siècle	Impressionnistes	Modernes	Total
classes populaires	67	2	8	1	4	3	10	5	100
classes moyennes	36	7,5	13	3	4	4,5	22	10	100
hautes classes	21	10	15,5	5	4	4	24	16,5	100
total	30	9	13,5	4,6	5	5	21,7	13,8	100

It would seem to be a question of revealing the process of cultural accumulation, especially active in the past decade, while taking account of the social and economic nature of the problem. Such a project must:

- 1 · be actualized, requiring the collaboration of qualified intellectual personnel (data processing analysts, linguists . . .)

- 2 · be scientifically accurate, based on statistical information supplied by a codification of artists.

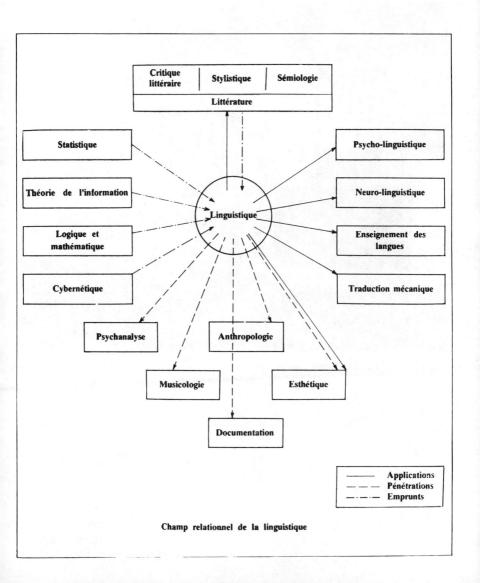

Champ relationnel de la linguistique

JOSEPH KOSUTH

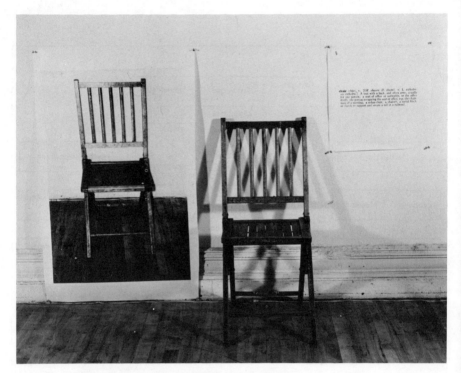

One and Three Chairs. 1965.

Photograph of presentation for
Matter in General
(*Art as Idea as Idea*). 1968. →

1. *Idea*, adopted from L, itself borrowed from Gr *idea* (ἰδέα), a concept, derives from Gr *idein* (s *id-*), to see, for **widein*. L *idea* has derivative LL adj *ideālis*, archetypal, ideal, whence EF-F *idéal* and E *ideal*, whence resp F *idéalisme* and E *idealism*, also resp *idéaliste* and *idealist*, and, further, *idéaliser* and *idealize*. L *idea* becomes MF-F *idée*, with cpd *idée fixe*, a fixed idea, adopted by E Francophiles; it also has ML derivative **ideāre*, pp **ideātus*, whence the Phil n *ideātum*, a thing that, in the fact, answers to the idea of it, whence 'to *ideate*', to form in, or as an, idea.

Titled (*Art as Idea as Idea*). 1967.

JOSEPH KOSUTH

Art After Philosophy*

The fact that it has recently become fashionable for physicists them-
selves to be sympathetic toward religion . . . marks the physicists'
own lack of confidence in the validity of their hypotheses, which is
a reaction on their part from the antireligious dogmatism of nine-
teenth-century scientists, and a natural outcome of the crisis through
which physics has just passed.—A. J. Ayer.

. . . once one has understood the *Tractatus* there will be no tempta-
tion to concern oneself anymore with philosophy, which is neither
empirical like science nor tautological like mathematics; one will,
like Wittgenstein in 1918, abandon philosophy, which, as traditionally
understood, is rooted in confusion.—J. O. Urmson.

Traditional philosophy, almost by definition, has concerned
itself with the *unsaid*. The nearly exclusive focus on the
said by twentieth-century analytical linguistic philosophers
is the shared contention that the *unsaid* is *unsaid* because
it is *unsayable*. Hegelian philosophy made sense in the nine-
teenth century and must have been soothing to a century
that was barely getting over Hume, the Enlightenment, and
Kant.[1] Hegel's philosophy was also capable of giving cover
for a defense of religious beliefs, supplying an alternative to
Newtonian mechanics, and fitting in with the growth of
history as a discipline, as well as accepting Darwinian
biology.[2] He appeared to give an acceptable resolution to
the conflict between theology and science, as well.

The result of Hegel's influence has been that a great
majority of contemporary philosophers are really little more
than *historians* of philosophy, Librarians of the Truth, so to
speak. One begins to get the impression that there "is
nothing more to be said." And certainly if one realizes the

* Reprinted from *Studio International* (October, 1969).
[1] Morton White, *The Age of Analysis* (New York: Mentor Books), p. 14.
[2] *Ibid.*, p. 15.

implications of Wittgenstein's thinking, and the thinking influenced by him and after him, "Continental" philosophy need not seriously be considered here.[3]

Is there a reason for the "unreality" of philosophy in our time? Perhaps this can be answered by looking into the difference between our time and the centuries preceding us. In the past man's conclusions about the world were based on the information he had about it—if not specifically like the empiricists, then generally like the rationalists. Often in fact, the closeness between science and philosophy was so great that scientists and philosophers were one and the same person. In fact, from the times of Thales, Epicurus, Heraclitus, and Aristotle to Descartes and Leibnitz, "the great names in philosophy were often great names in science as well."[4]

That the world as perceived by twentieth-century science is a vastly different one than the one of its preceding century, need not be proved here. Is it possible, then, that in effect man has learned so much, and his "intelligence" is such, that he cannot *believe* the reasoning of traditional philosophy? That perhaps he knows too much about the world to make those *kinds* of conclusions? As Sir James Jeans has stated:

. . . When philosophy has availed itself of the results of science, it has not been by borrowing the abstract mathematical description of the pattern of events, but by borrowing the then current pictorial description of this pattern; thus it has not appropriated certain knowledge but conjectures. These conjectures were often good enough for the man-sized world, but not, as we now know, for those ultimate processes of nature which control the happenings of the man-sized world, and bring us nearest to the true nature of reality.[5]

He continues:

One consequence of this is that the standard philosophical discussions of many problems, such as those of causality and free will or

[3] I mean by this Existentialism and Phenomenology. Even Merleau-Ponty, with his middle-of-the-road position between empiricism and rationalism, cannot express his philosophy without the use of words (thus using concepts); and following this, how can one discuss experience without sharp distinctions between ourselves and the world?

[4] Sir James Jeans, *Physics and Philosophy* (Ann Arbor, Mich.: University of Michigan Press), p. 17.

[5] *Ibid.*, p. 190.

of materialism or mentalism, are based on an interpretation of the pattern of events which is no longer tenable. The scientific basis of these older discussions has been washed away, and with their disappearance have gone all the arguments . . .[6]

The twentieth century brought in a time that could be called "the end of philosophy and the beginning of art." I do not mean that, of course, strictly speaking, but rather as the "tendency" of the situation. Certainly linguistic philosophy can be considered the heir to empiricism, but it's a philosophy in one gear.[7] And there is certainly an "art condition" to art preceding Duchamp, but its other functions or reasons-to-be are so pronounced that its ability to function clearly as art limits its art condition so drastically that it's only minimally art.[8] In no mechanistic sense is there a connection between philosophy's "ending" and art's "beginning," but I don't find this occurrence entirely coincidental. Though the same reasons may be responsible for both occurrences, the connection is made by me. I bring this all up to analyze art's function and subsequently its viability. And I do so to enable others to understand the reasoning of my—and, by extension, other artists'—art, as well to provide a clearer understanding of the term "Conceptual art."[9]

THE FUNCTION OF ART

The main qualifications to the lesser position of painting is that advances in art are certainly not always formal ones.—Donald Judd (1963).

Half or more of the best new work in the last few years has been neither painting nor sculpture.—Donald Judd (1965).

Everything sculpture has, my work doesn't.—Donald Judd (1967).

The idea becomes a machine that makes the art.—Sol LeWitt (1965)

[6] *Ibid.*, p. 190.
[7] The task such philosophy has taken upon itself is the only "function" it could perform without making philosophic assertions.
[8] This is dealt with in the following section.
[9] I would like to make it clear, however, that I intend to speak for no one else. I arrived at these conclusions alone, and indeed, it is from this thinking that my art since 1966 (if not before) evolved. Only recently did I realize after meeting Terry Atkinson that he and Michael Baldwin share similar, though certainly not identical, opinions to mine.

The one thing to say about art is that it is one thing. Art is art-as-art and everything else is everything else. Art as art is nothing but art. Art is not what is not art.—Ad Reinhardt (1963).

The meaning is the use.—Wittgenstein.

A more functional approach to the study of concepts has tended to replace the method of introspection. Instead of attempting to grasp or describe concepts bare, so to speak, the psychologist investigates the way in which they function as ingredients in beliefs and in judgments.—Irving M. Copi.

Meaning is always a presupposition of function.—T. Segerstedt.

. . . the subject matter of conceptual investigations is the *meaning* of certain words and expressions—and not the things and states of affairs themselves about which we talk, when using those words and expressions.—G. H. Von Wright.

Thinking is radically metaphoric. Linkage by analogy is its constituent law or principle, its causal nexus, since meaning only arises through the causal *contexts* by which a sign stands for (takes the place of) an instance of a sort. To think of anything is to take it *as* of a sort (as a such and such) and that "as" brings in (openly or in disguise) the analogy, the parallel, the metaphoric grapple or ground or grasp or draw by which alone the mind takes hold. It takes no hold if there is nothing for it to haul from, for its thinking is the haul, the attraction of likes.—I. A. Richards.

In this section I will discuss the separation between aesthetics and art; consider briefly formalist art (because it is a leading proponent of the idea of aesthetics as art), and assert that art is analogous to an analytic proposition, and that it is art's existence as a tautology that enables art to remain "aloof" from philosophical presumptions.

It is necessary to separate aesthetics from art because aesthetics deals with opinions on perception of the world in general. In the past one of the two prongs of art's function was its value as decoration. So any branch of philosophy that dealt with "beauty" and thus, taste, was inevitably duty bound to discuss art as well. Out of this "habit" grew the notion that there was a conceptual connection between art and aesthetics, which is not true. This idea never drastically conflicted with artistic considerations before recent times, not only because the morphological characteristics of

art perpetuated the continuity of this error, but as well, because the apparent other "functions" of art (depiction of religious themes, portraiture of aristocrats, detailing of architecture, etc.) used art to cover up art.

When objects are presented within the context of art (and until recently objects always have been used) they are as eligible for aesthetic consideration as are any objects in the world, and an aesthetic consideration of an object existing in the realm of art means that the object's existence or functioning in an art context is irrelevant to the aesthetic judgment.

The relation of aesthetics to art is not unlike that of aesthetics to architecture, in that architecture has a very specific *function* and how "good" its design is is *primarily* related to how well it performs its function. Thus, judgments on what it looks like correspond to taste, and we can see that throughout history different examples of architecture are praised at different times depending on the aesthetics of particular epochs. Aesthetic thinking has even gone so far as to make examples of architecture not related to "art" at all, works of art in themselves (e.g., the pyramids of Egypt).

Aesthetic considerations are indeed *always* extraneous to an object's function or "reason-to-be." Unless of course, that object's reason-to-be is strictly aesthetic. An example of a purely aesthetic object is a decorative object, for decoration's primary function is "to add something to, so as to make more attractive; adorn; ornament,"[10] and this relates directly to taste. And this leads us directly to "formalist" art and criticism.[11] Formalist art (painting and sculpture) is the vanguard of decoration, and, strictly speaking, one could reasonably assert that its art condition is so minimal that for all functional purposes it is not art at all, but pure exercises in aesthetics. Above all things Clement Greenberg is the critic of taste. Behind every one of his decisions is an aesthetic judgment, with those judgments reflecting his taste.

[10] *Webster's New World Dictionary of the American Language.*

[11] The conceptual level of the work of Kenneth Noland, Jules Olitski, Morris Louis, Ron Davis, Anthony Caro, John Hoyland, Dan Christensen, *et al.,* is so dismally low, that any that is there is supplied by the critics promoting it. This is seen later.

And what does his taste reflect? The period he grew up in as a critic, the period "real" for him: the fifties.[12]

How else can one account for, given his theories—if they have any logic to them at all—his disinterest in Frank Stella, Ad Reinhardt, and others applicable to his historical scheme? Is it because he is ". . . basically unsympathetic on personally experiential grounds.[13] Or, in other words, "their work doesn't suit his taste?"

But in the philosophic *tabula rasa* of art, "if someone calls it art," as Don Judd has said, "it's art." Given this, formalist painting and sculpture can be granted an "art condition," but only by virtue of their presentation in terms of their art idea (e.g., a rectangular-shaped canvas stretched over wooden supports and stained with such and such colors, using such and such forms, giving such and such a visual experience, etc.). If one looks at contemporary art in this light one realizes the minimal creative effort taken on the part of formalist artists specifically, and all painters and sculptors (working as such today) generally.

This brings us to the realization that formalist art and criticism accepts as a definition of art one that exists solely on morphological grounds. While a vast quantity of similar looking objects or images (or visually related objects or images) may seem to be related (or connected) because of a similarity of visual/experiential "readings," one cannot claim from this an artistic or conceptual relationship.

It is obvious then that formalist criticism's reliance on morphology leads necessarily with a bias toward the morphology of traditional art. And in this sense their criticism is not related to a "scientific method" or any sort of empiricism (as Michael Fried, with his detailed descriptions of paintings and other "scholarly" paraphernalia would want us to believe). Formalist criticism is no more than an analysis of the physical attributes of particular objects that happen to

[12] Michael Fried's reasons for using Greenberg's rationale reflect his background (and most of the other formalist critics) as a "scholar," but more of it is due to his desire, I suspect, to bring his scholarly studies into the modern world. One can easily sympathize with his desire to connect, say, Tiepolo with Jules Olitski. One should never forget, however, that a historian loves history more than anything, even art.

[13] Lucy Lippard uses this quotation in a footnote to Ad Reinhardt's retrospective catalogue, January, 1967, p. 28.

exist in a morphological context. But this doesn't add any knowledge (or facts) to our understanding of the nature or function of art. And neither does it comment on whether or not the objects analyzed are even works of art, in that formalist critics always bypass the conceptual element in works of art. Exactly why they don't comment on the conceptual element in works of art is precisely because formalist art is only art by virtue of its resemblance to earlier works of art. It's a mindless art. Or, as Lucy Lippard so succinctly described Jules Olitski's paintings: "they're visual *Muzak*."[14]

Formalist critics and artists alike do not question the nature of art, but as I have said elsewhere:

Being an artist now means to question the nature of art. If one is questioning the nature of painting, one cannot be questioning the nature of art. If an artist accepts painting (or sculpture) he is accepting the tradition that goes with it. That's because the word art is general and the word painting is specific. Painting is a *kind* of art. If you make paintings you are already accepting (not questioning) the nature of art. One is then accepting the nature of art to be the European tradition of a painting-sculpture dichotomy.[15]

The strongest objection one can raise against a morphological justification for traditional art is that morphological notions of art embody an implied à priori concept of art's possibilities. And such an a priori concept of the nature of art (as separate from analytically framed art propositions or "work," which I will discuss later) makes it, indeed, a priori: impossible to question the nature of art. And this questioning of the nature of art is a very important concept in understanding the function of art.

The function of art, as a question, was first raised by Marcel Duchamp. In fact it is Marcel Duchamp whom we can credit with giving art its own identity. (One can certainly see a tendency toward this self-identification of art beginning with Manet and Cézanne through to Cubism,[16] but their works are timid and ambiguous by comparison with Du-

14 Lucy Lippard, "Constellation by Harsh Daylight: The Whitney Annual," *Hudson Review,* Vol. 21, No. 1 (Spring, 1968).

15 Arthur R. Rose, "Four Interviews," *Arts Magazine* (February, 1969).

16 As Terry Atkinson pointed out in his introduction to *Art-Language* (Vol. 1, No. 1), the Cubists never questioned *if* art had morphological characteristics, but *which* ones in *painting* were acceptable.

champ's.) "Modern" art and the work before seemed connected by virtue of their morphology. Another way of putting it would be that art's "language" remained the same, but it was saying new things. The event that made conceivable the realization that it was possible to "speak another language" and still make sense in art was Marcel Duchamp's first unassisted Ready-made. With the unassisted Ready-made, art changed its focus from the form of the language to what was being said. Which means that it changed the nature of art from a question of morphology to a question of function. This change—one from "appearance" to "conception"—was the beginning of "modern" art and the beginning of conceptual art. All art (after Duchamp) is conceptual (in nature) because art only exists conceptually.

The "value" of particular artists after Duchamp can be weighed according to how much they questioned the nature of art; which is another way of saying "what they *added* to the conception of art" or what wasn't there before they started. Artists question the nature of art by presenting new propositions as to art's nature. And to do this one cannot concern oneself with the handed-down "language" of tradiional art, as this activity is based on the assumption that there is only one way of framing art propositions. But the very stuff of art is indeed greatly related "creating" new propositions.

The case is often made—particularly in reference to Duchamp—that objects of art (such as the Ready-mades, of course, but all art is implied in this) are judged as *objets d'art* in later years and the artists' *intentions* become irrelevant. Such an argument is the case of a preconceived notion ordering together not necessarily related facts. The point is this: aesthetics, as we have pointed out, are conceptually irrelevant to art. Thus, any physical thing can become *objet d'art,* that is to say, can be considered tasteful, aesthetically pleasing, etc. But this has no bearing on the object's application to an art context; that is, its *functioning* in an art context. (E.g., if a collector takes a painting, attaches legs, and uses it as a dining table it's an act unrelated to art or the artist because, *as art,* that wasn't the artist's *intention.*)

And what holds true for Duchamp's work applies as well to most of the art after him. In other words, the value of Cub-

ism—for instance—is its idea in the realm of art, not the physical or visual qualities seen in a specific painting, or the particularization of certain colors or shapes. For these colors and shapes are the art's "language," not its meaning conceptually as art. To look upon a Cubist "master-work" *now* as art is nonsensical, conceptually speaking, as far as art is concerned. (That visual information that was unique in Cubism's language has now been generally absorbed and has a lot to do with the way in which one deals with painting "linguistically." [E.g., what a Cubist painting meant experimentally and conceptually to, say, Gertrude Stein, is beyond our speculation because the same painting then "meant" something different than it does now.]) The "value" now of an original Cubist painting is not unlike, in most respects, an original manuscript by Lord Byron, or *The Spirit of St. Louis* as it is seen in the Smithsonian Institution. (Indeed, museums fill the very same function as the Smithsonian Institution—why else would the *Jeu de Paume* wing of the Louvre exhibit Cézanne's and Van Gogh's palettes as proudly as they do their paintings?) Actual works of art are little more than historical curiosities. As far as *art* is concerned Van Gogh's paintings aren't worth any more than his palette is. They are both "collector's items."[17]

Art "lives" through influencing other art, not by existing as the physical residue of an artist's ideas. The reason that different artists from the past are "brought alive" again is because some aspect of their work becomes "usable" by living artists. That there is no "truth" as to what art is seems quite unrealized.

What is the function of art, or the nature of art? If we continue our analogy of the forms art takes as being art's *language* one can realize then that a work of art is a kind of *proposition* presented within the context of art as a comment on art. We can then go further and analyze the types of "propositions."

A. J. Ayer's evaluation of Kant's distinction between analytic and synthetic is useful to us here: "A proposition is

[17] When someone "buys" a Flavin he isn't buying a light show, for if he was he could just go to a hardware store and get the goods for considerably less. He isn't "buying" anything. He is subsidizing Flavin's activity as an artist.

analytic when its validity depends solely on the definitions of the symbols it contains, and synthetic when its validity is determined by the facts of experience."[18] The analogy I will attempt to make is one between the art condition and the condition of the analytic proposition. In that they don't appear to be believable as anything else, or be about anything (other than art) the forms of art most clearly finally referable only to art have been forms closest to analytical propositions.

Works of art are analytic propositions. That is, if viewed within their context—as art—they provide no information whatsoever about any matter of fact. A work of art is a tautology in that it is a presentation of the artist's intention, that is, he is saying that that particular work of art *is* art, which means, is a *definition* of art. Thus, that it is art is true a priori (which is what Judd means when he states that "if someone calls it art, it's art").

Indeed, it is nearly impossible to discuss art in general terms without talking in tautologies—for to attempt to "grasp" art by any other "handle" is merely to focus on another aspect or quality of the proposition, which is usually irrelevant to the artwork's "art condition." One begins to realize that art's "art condition" is a conceptual state. That the language forms that the artist frames his propositions in are often "private" codes or languages is an inevitable outcome of art's freedom from morphological constrictions; and it follows from this that one has to be familiar with contemporary art to appreciate it and understand it. Likewise one understands why the "man in the street" is intolerant to artistic art and always demands art in a traditional "language." (And one understands why formalist art sells "like hot cakes.") Only in painting and sculpture did the artists all speak the same language. What is called "Novelty Art" by the formalists is often the attempt to find new languages, although a new language doesn't necessarily mean the framing of new propositions: e.g., most kinetic and electronic art.

Another way of stating, in relation to art, what Ayer asserted about the analytic method in the context of lan-

[18] A. J. Ayer, *Language, Truth, and Logic* (New York: Dover Publications), p. 78.

guage would be the following: The validity of artistic propositions is not dependent on any empirical, much less any aesthetic, presupposition about the nature of things. For the artist, as an analyst, is not directly concerned with the physical properties of things. He is concerned only with the way (1) in which art is capable of conceptual growth and (2) how his propositions are capable of logically following that growth.[19] In other words, the propositions of art are not factual, but linguistic in *character*—that is, they do not describe the behavior of physical, or even mental objects; they express definitions of art, or the formal consequences of definitions of art. Accordingly, we can say that art operates on a logic. For we shall see that the characteristic mark of a purely logical inquiry is that it is concerned with the formal consequences of our definitions (of art) and not with questions of empirical fact.[20]

To repeat, what art has in common with logic and mathematics is that it is a tautology; i.e., the "art idea" (or "work") and art are the same and can be appreciated as art without going outside the context of art for verification.

On the other hand, let us consider why art cannot be (or has difficulty when it attempts to be) a synthetic proposition. Or, that is to say, when the truth or falsity of its assertion is verifiable on empirical grounds. Ayer states:

. . . The criterion by which we determine the validity of an a priori or analytical proposition is not sufficient to determine the validity of an empirical or synthetic proposition. For it is characteristic of empirical propositions that their validity is not purely formal. To say that a geometrical proposition, or a system of geometrical propositions, is false, is to say that it is self-contradictory. But an empirical proposition, or a system of empirical propositions, may be free from contradiction and still be false. It is said to be false, not because it is formally defective, but because it fails to satisfy some material criterion.[21]

The unreality of "realistic" art is due to its framing as an art proposition in synthetic terms: one is always tempted to "verify" the proposition empirically. Realism's synthetic

[19] *Ibid.,* p. 57.
[20] *Ibid.,* p. 57.
[21] *Ibid.,* p. 90.

state does not bring one to a circular swing back into a dialogue with the larger framework of questions about the nature of *art* (as does the work of Malevich, Mondrian, Pollock, Reinhardt, early Rauschenberg, Johns, Lichtenstein, Warhol, Andre, Judd, Flavin, LeWitt, Morris, and others), but rather, one is flung out of art's "orbit" into the "infinite space" of the human condition.

Pure Expressionism, continuing with Ayer's terms, could be considered as such: "A sentence which consisted of demonstrative symbols would not express a genuine proposition. It would be a mere ejaculation, in no way characterizing that to which it was supposed to refer." Expressionist works are usually such "ejaculations" presented in the morphological language of traditional art. If Pollock is important it is because he painted on loose canvas horizontally to the floor. What *isn't* important is that he later put those drippings over stretchers and hung them parallel to the wall. (In other words what is important in art is what one *brings* to it, not one's adoption of what was previously existing.) What is even less important to art is Pollock's notions of "self-expression" because those *kinds* of subjective meanings are useless to anyone other than those involved with him personally. And their "specific" quality puts them outside of art's context.

"I do not make art," Richard Serra says, "I am engaged in an activity; if someone wants to call it art, that's his business, but it's not up to me to decide that. That's all figured out later." Serra, then, is very much aware of the implications of his work. If Serra is indeed just "figuring out what lead does" (gravitationally, molecularly, etc.), why should *anyone* think of it as art? If he doesn't take the responsibility of it being art, who can, or should? His work certainly appears to be empirically verifiable: lead can do, and be used for, many physical activities. In itself this does anything but lead us into a dialogue about the nature of art. In a sense then he is a primitive. He has no idea about art. How is it then that we know about "his activity"? Because he has told us it is art by his actions *after* "his activity" has taken place. That is, by the fact that he is with several galleries, puts the physical residue of his activity in museums (and sells them to art collectors—but as we have pointed out,

collectors are irrelevant to the "condition of art" of a work). That he denies his work is art but plays the artist is more than just a paradox. Serra secretly feels that "arthood" is arrived at empirically. Thus, as Ayer has stated:

There are no absolutely certain empirical propositions. It is only tautologies that are certain. Empirical questions are one and all hypotheses, which may be confirmed or discredited in actual sense experience. And the propositions in which we record the observations that verify these hypotheses are themselves hypotheses which are subject to the test of further sense experience. Thus there is no final proposition.[22]

What one finds all throughout the writings of Ad Reinhardt is this very similar thesis of "art-as-art," and that "art is always dead, and a 'living' art is a deception."[23] Reinhardt had a very clear idea about the nature of art, and his importance is far from recognized.

Because forms of art that can be considered synthetic propositions are verifiable by the world, that is to say, to understand these propositions one must leave the tautological-like framework of art and consider "outside" information. But to consider it as art it is necessary to ignore this same outside information, because outside information (experiential qualities, to note) has its own* intrinsic worth. And to comprehend this worth one does not need a state of "art condition."

From this it is easy to realize that art's viability is not connected to the presentation of visual (or other) kinds of experience. That that may have been one of art's extraneous functions in the preceding centuries is not unlikely. After all, man in even the nineteenth century lived in a fairly standardized visual environment. That is, it was ordinarily predictable as to what he would be coming into contact with day after day. His visual environment in the part of the world in which he lived was fairly consistent. In our time we have an experientially drastically richer environment. One can fly all over the earth in a matter of hours and days, not months. We have the cinema, and color television, as

[22] *Ibid.*, p. 94.
[23] Ad Reinhardt's retrospective catalogue (Jewish Museum, January, 1967) written by Lucy Lippard, p. 12.

well as the man-made spectacle of the lights of Las Vegas or the skyscrapers of New York City. The whole world is there to be seen, and the whole world can watch man walk on the moon from their living rooms. Certainly art or objects of painting and sculpture cannot be expected to compete experientially with this?

The notion of "use" is relevant to art and its "language." Recently the box or cube form has been used a great deal within the context of art. (Take for instance its use by Judd, Morris, LeWitt, Bladen, Smith, Bell, and McCracken—not even mentioning the quantity of boxes and cubes that came after.) The difference between all the various uses of the box or cube form is directly related to the differences in the intentions of the artists. Further, as is particularly seen in Judd's work, the use of the box or cube form illustrates very well our earlier claim that an object is only art when placed in the context of art.

A few examples will point this out. One could say that if one of Judd's box forms was seen filled with debris, seen placed in an industrial setting, or even merely seen sitting on a street corner, it would not be identified with art. It follows then that understanding and consideration of it as an artwork is necessary a priori to viewing it in order to "see" it as a work of art. Advance information about the concept of art and about an artist's concepts is necessary to the appreciation and understanding of contemporary art. Any and all of the physical attributes (qualities) of contemporary works, if considered separately and/or specifically, are irrelevant to the art concept. The art concept (as Judd said, though he didn't mean it this way) must be considered in its whole. To consider a concept's parts is invariably to consider aspects that are irrelevant to its art condition—or like reading *parts* of a definition.

It comes as no surprise that the art with the least fixed morphology is the example from which we decipher the nature of the general term "art." For where there is a context existing separately of its morphology and consisting of its function one is more likely to find results less conforming and predictable. It is in modern art's possession of a "language" with the shortest history that the plausibility of the abandonment of that "language" becomes most possible.

It is understandable then that the art that came out of Western painting and sculpture is the most energetic, questioning (of its nature), and the least assuming of all the general "art" concerns. In the final analysis, however, all of the arts have but (in Wittgenstein's terms) a "family" resemblance.

Yet the various qualities relatable to an "art condition" possessed by poetry, the novel, the cinema, the theatre, and various forms of music, etc., is that aspect of them most reliable to the function of art as asserted here.

Is not the decline of poetry relatable to the implied metaphysics from poetry's use of "common" language as an art language?[24] In New York the last decadent stages of poetry can be seen in the move by "Concrete" poets recently toward the use of actual objects and theatre.[25] Can it be that they feel the unreality of their art form?

We see now that the axioms of a geometry are simply definitions, and that the theorems of a geometry are simply the logical consequences of these definitions. A geometry is not in itself about physical space; in itself it cannot be said to be "about" anything. But we can use a geometry to reason about physical space. That is to say, once we have given the axioms a physical interpretation, we can proceed to apply the theorems to the objects which satisfy the axioms. Whether a geometry can be applied to the actual physical world or not, is an empirical question which falls outside the scope of geometry itself. There is no sense, therefore, in asking which of the various geometries known to us are false and which are true. Insofar as they are all free from contradiction, they are all true. The proposition which states that a certain application of a geometry is possible is not itself a proposition of that geometry. All that the geometry itself tells us is that if anything can be brought under the definitions, it will also satisfy the theorems. It is therefore a purely logical system, and its propositions are purely analytic propositions.—A. J. Ayer[26]

24 It is poetry's use of common language to attempt to *say the unsayable* that is problematic, not any inherent problem in the use of language within the context of art.

25 Ironically, many of them call themselves "Conceptual Poets." Much of this work is very similar to Walter de Maria's work and this is not coincidental; de Maria's work functions as a kind of "object" poetry, and his intentions are very poetic: he really wants his work to change men's lives.

26 *Op. cit.*, p. 82.

Here then I propose rests the viability of art. In an age when traditional philosophy is unreal because of its assumptions, art's ability to exist will depend not only on its *not* performing a service—as entertainment, visual (or other) experience, or decoration—which is something easily replaced by kitsch culture, and technology, but, rather, it will remain viable by *not* assuming a philosophical stance; for in art's unique character is the capacity to remain aloof from philosophical judgments. It is in this context that art shares similarities with logic, mathematics, and, as well, science. But whereas the other endeavors are useful, art is not. Art indeed exists for its own sake.

In this period of man, after philosophy and religion, art may possibly be one endeavor that fulfills what another age might have called "man's spiritual needs." Or, another way of putting it might be that art deals analogously with the state of things "beyond physics" where philosophy had to make assertions. And art's strength is that even the preceding sentence is an assertion, and cannot be verified by art. Art's only claim is for art. Art is the definition of art.

Joseph Kosuth: *Information Room.* 1970.

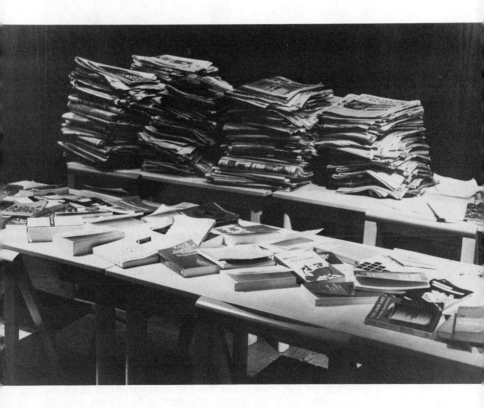

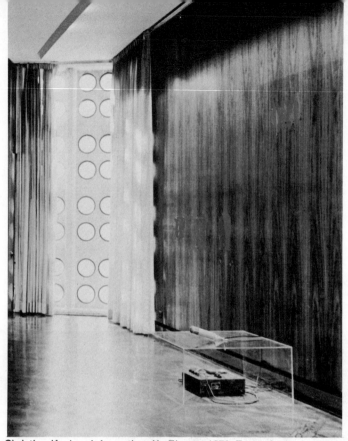

Christine Kozlov: *Information: No Theory.* 1970. Tape piece.

INFORMATION: NO THEORY

1. THE RECORDER IS EQUIPPED WITH A CONTINUOUS LOOP TAPE.

2. FOR THE DURATION OF THE EXHIBITION (APRIL 9 TO AUGUST 23) THE TAPE RECORDER WILL BE SET AT "RECORD" ALL THE SOUNDS AUDIBLE IN THIS ROOM DURING THAT TIME WILL BE RECORDED.

3. THE NATURE OF THE LOOP TAPE NECESSITATES THAT NEW INFORMATION ERASES OLD INFORMATION. THE "LIFE" OF THE INFORMATION, THAT IS, THE TIME IT TAKES FOR THE INFORMATION TO GO FROM "NEW" TO "OLD" IS APPROXIM-ATELY TWO (2) MINUTES.

4. PROOF OF THE EXISTENCE OF THE INFORMATION DOES IN FACT NOT EXIST IN ACTUALITY, BUT IS BASED ON PROBABILITY.

CHRISTINE KOZLOV, March, 1971

ACTIVITIES FROM 1965: (1) NEUROLOGICAL COMPILA-
TION. MAJOR RESEARCH ON THE PHYSICAL MIND. (2)
INFORMATION: NO THEORY. A RECORDER EQUIPPED
WITH A LOOP TAPE SO THAT AS NEW SOUNDS ARE
RECORDED THE PREVIOUS SOUNDS RECORDED ARE
ERASED. (3) TELEGRAM WITH STATEMENT CONTAINING
NO INFORMATION. (4) A SERIES OF CABLES SENT DUR-
ING THE EXHIBITION SUPPLYING FACTS ABOUT THE
AMOUNT OF CONCEPTS REJECTED DURING THAT TIME.
(5) FIGURATIVE WORK. A LISTING OF EVERYTHING
EATEN FOR A PERIOD OF SIX MONTHS. (6) 271 BLANK
SHEETS OF PAPER CORRESPONDING TO 271 DAYS OF
CONCEPTS REJECTED. (7) RECORDED SOUND OF BELL
TELEPHONE OPERATOR STATING TIME (DURATION 24
HOURS). (8) INFORMATION DRIFT: COMBINED RECORD-
ING OF NEWS BULLETINS OF THE SHOOTINGS OF ANDY
WARHOL AND ROBERT KENNEDY. (9) FILM NO. 2 WHITE
LEDER-16MM-100 FEET. (10) FILM NO. 1 ALL BLACK (EX-
POSED) 8MM-100 FEET. (11) PRACTICE PROJECT, SYS-
TEM/STRUCTURE: CONTEXT OF LEARNING HOW TO
TYPE. (12) COMPOSITIONS FOR AUDIO STRUCTURE—A
CODING SYSTEM FOR SOUND.

Telegram Western union

(05)BC246

SSA267 B FHFBPEY KG PDF TDFH NEW YORK NY 1 1235P EST

DONALD KARSHAN, NEW YORK CULTURAL CENTER

(BON 20) 2 COLUMBUS CIRCLE NYF

PARTICULARS RELATED TO THE INFORMATION NOT CONTAINED HEREIN

CONSTITUTE THE FORM OF THIS ACTION

C KOZLOV

(1252).

SOL LEWITT

*Sentences on Conceptual Art, 1968**

1) Conceptual Artists are mystics rather than rationalists. They leap to conclusions that logic cannot reach.

2) Rational judgments repeat rational judgments.

3) Illogical judgments lead to new experience.

4) Formal art is essentially rational.

5) Irrational thoughts should be followed absolutely and logically.

6) If the artist changes his mind midway through the execution of the piece he compromises the result and repeats past results.

7) The artist's will is secondary to the process he initiates from idea to completion. His willfulness may only be ego.

8) When words such as painting and sculpture are used, they connote a whole tradition and imply a consequent acceptance of this tradition, thus placing limitations on the artist who would be reluctant to make art that goes beyond the limitations.

9) The concept and idea are different. The former implies a general direction while the latter is the component. Ideas implement the concept.

10) Ideas alone can be works of art; they are in a chain of development that may eventually find some form. All ideas need not be made physical.

11) Ideas do not necessarily proceed in logical order. They may set one off in unexpected directions but an idea must necessarily be completed in the mind before the next one is formed.

12) For each work of art that becomes physical there are many variations that do not.

13) A work of art may be understood as a conductor from the artists' mind to the viewers. But it may never reach the viewer, or it may never leave the artists' mind.

14) The words of one artist to another may induce a chain of ideas, if they share the same concept.

15) Since no form is intrinsically superior to another, the

* Reprinted from *Art-Language,* Vol. 1, No. 1 (1969).

artist may use any form, from an expression of words (written or spoken) to physical reality, equally.

16) If words are used, and they proceed from ideas about art, then they are art and not literature, numbers are not mathematics.

17) All ideas are art if they are concerned with art and fall within the conventions of art.

18) One usually understands the art of the past by applying the conventions of the present thus misunderstanding the art of the past.

19) The conventions of art are altered by works of art.

20) Successful art changes our understanding of the conventions by altering our perceptions.

21) Perception of ideas leads to new ideas.

22) The artist cannot imagine his art, and cannot perceive it until it is complete.

23) One artist may misperceive (understand it differently from the artist) a work of art but still be set off in his own chain of thought by that misconstruing.

24) Perception is subjective.

25) The artist may not necessarily understand his own art. His perception is neither better nor worse than that of others.

26) An artist may perceive the art of others better than his own.

27) The concept of a work of art may involve the matter of the piece or the process in which it is made.

28) Once the idea of the piece is established in the artist's mind and the final form is decided, the process is carried out blindly. There are many side effects that the artist cannot imagine. These may be used as ideas for new works.

29) The process is mechanical and should not be tampered with. It should run its course.

30) There are many elements involved in a work of art. The most important are the most obvious.

31) If an artist uses the same form in a group of works and changes the material, one would assume the artist's concept involved the material.

32) Banal ideas cannot be rescued by beautiful execution.

33) It is difficult to bungle a good idea.

34) When an artist learns his craft too well he makes slick art.

35) These sentences comment on art, but are not art.

Sol LeWitt: *Composite.* 1970.

Sol LeWitt. 1970.

Six thousand two hundred and fifty-five lines

179

Fibonacci 1202
Mario Merz 1970

esplorazione di uno
spazio biologico

investigation of
biological space

abbandonare il progetto
di catturare coprire
e uccidere lo spazio

Abandon the project
of capturing
and killing space

1
1
2
3
5
8
13
21
34
55
89
144
233
377
610
987
1597
2584
4181
6765
10946
17711
28657
46368
75025
121393
196418
317811
514229
832040
1346269
2178309
3524578
5702887
9227465
14930352
24157817
39088169
63245986
102334155
165580141
267914296
433494437
701408733
1134903170
1836311903
2971215073
4807526976
7778741999
12586269025
20365011074
32951280099
53316291173
86267571272
139583862445

↑ igloo
 Fibonacci
↓

ricerca del modulo per pro
cedere a tracciare una
spirale secondo la serie
di Fibonacci

stabilire il centro del
piano della casa

Research on the unit of
measurement to be used
in drawing a spiral
according to the
Fibonacci numerical series

Establishing the centre of
the house plan

la spirale incontra
la linea di direzione
ai punti indicati
dalla numerazione

the spiral meets
the line of direction
at the enumerated
points

tracciare una linea
dal centro

trace a line
from the center

numerare la linea
secondo la serie di
numeri di Fibonacci
stabilendo il modulo
di 1° metro

enumerating the line
with the beginning of
the Fibonacci numerical
series establishing the
measuring unit of
one metre

ROBERT MORRIS
*Statements, 1970**

"In a broad sense art has always been an object, static and final, even though structurally it may have been a depiction or existed as a fragment. What is being attacked, however, is something more than art as an icon. Under attack is the rationalistic notion that art is a form of work that results in a finished product. Duchamp, of course, attacked the Marxist notion that labor was an index of value, but the Ready-mades are traditionally iconic art-objects. What art now has in its hand is mutable stuff which need not arrive at the point of being finalized with respect to either time or space. The notion that work is an irreversible process ending in a static icon-object no longer has much relevance."

"The attention given to both matter and its inseparableness from the process of change is not an emphasis on the phenomenon of means. What is revealed is that art itself is an activity of change, of disorientation and shift, of violent discontinuity and mutability, of the willingness for confusion even in the service of discovering new perceptual modes."

* Quotes from the "Conceptual Art and Conceptual Aspects" Exhibition, 1970. The New York Cultural Center, New York.

The Card File. 1962. →

185

BRUCE NAUMAN

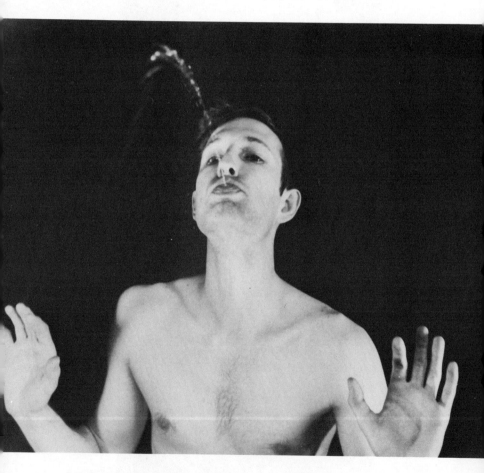

Portrait of the Artist as a Fountain. 1966.

BRUCE NAUMAN, March 2, 1970

Drill a hole into the heart of a large tree and insert a microphone.
Mount the amplifier and speaker in an empty room and adjust the
volume to make audible any sound that might come from the tree.

September, 1969

Drill a hole about a mile into the earth and drop a microphone to
within a few feet of the bottom. Mount the amplifier and speaker
in a very large empty room and adjust the volume to make audible any
sounds that might come from the cavity.

September, 1969

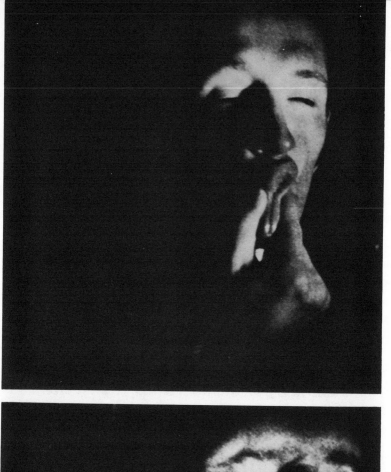

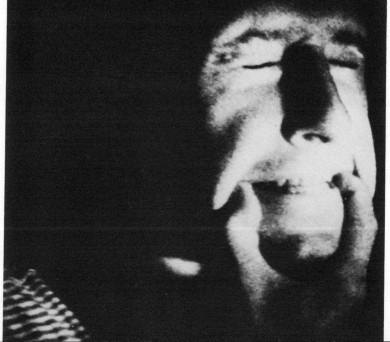

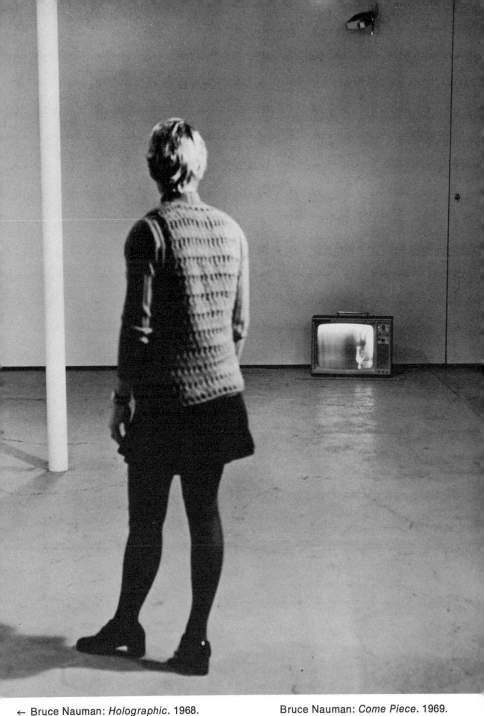

← Bruce Nauman: *Holographic.* 1968.
Holograms (Making Faces). 1968.

Bruce Nauman: *Come Piece.* 1969.

189

Bruce Nauman: *Bound to Fail*. 1967–70.

Bruce Nauman: *Drill Team.* 1966–70.

IAIN BAXTER*
(President, N.E. Thing Co. Ltd.)

"I feel I am the new Hudson River School traditionalist, using water, air, sky, land, clouds, and boats."

"Canvas, which should be left for the tent- and awning-makers, is returning in my work in the form of tents and awnings."

"Magazine reproductions are part of today's landscape."

"N.E. Thing Co. is anything."

* Quotes from the catalogue of the "Conceptual Art and Conceptual Aspects" Exhibition, 1970. The New York Cultural Center, New York.

ACT #83: Carl Andre's *Unmodified Rock Pile
in Colorado and Shape of Rock in Flight* (note arrow). 1968.

Xerox Telecopier II

The Xerox Telecopier II transmits and receives exact

facsimiles of anything printed, written, typed or drawn — across ordinary telephone lines. Short messages (e.g. action-authorizing signatures) can be sent in a minute or less. A complete 8½" x 11" page of any graphic material can be transmitted in just six minutes.

Telecopier II is as simple to operate as your telephone. Anybody can learn with a few minutes of training. And Telecopier II is easy to install. You can plug it in to any standard electrical outlet. A handy, self-test feature permits spot checks to verify proper performance.

ACT #113 - XEROX TELECOPIER II
AND WHOLE CONCEPT
OF TRANSCEIVING (1969)

Iain Baxter: *Paint into Earth.* 1969.

DENNIS OPPENHEIM

Energy Displacement—Approaching Theatricality, 1970. Participants: Art Department of the University of Wisconsin at Whitewater. Event: 50-meter freestyle (artists instructed to perform at full output). Finish recorded. Artists presented with tickets to Ambassador Theatre, 215 West Forty-ninth Street, New York City, N.Y. Seating arrangement determined by placement in race.

Energy Displacement—Approaching Theatricality. 1970.

FRONT MEZZANINE ROW "AA" OVERHANGS ORCHESTRA ROW "H"

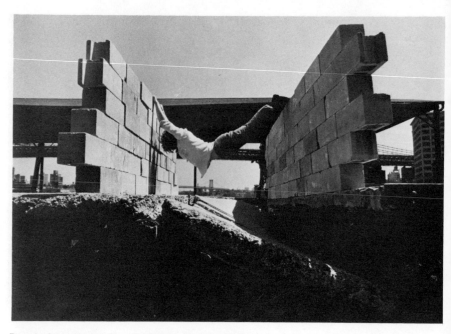

Dennis Oppenheim: *Parallel Stress* (Part I). 1970.

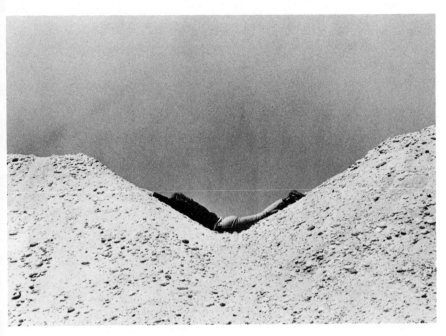

Dennis Oppenheim: *Parallel Stress* (Part II/Bottom). 1970.

JOHN PERREAULT

"ABCDEFGH IJKLMNOP QRSTUVW XYZ"
(ALPHABET)

The alphabet is a universal ordering system within our culture and an arbitrary one. Practically everyone knows the order of the letters of the alphabet. It is one of the first things a child is taught and yet there is no inherent logic to the actual ordering of the letters. Nevertheless, the alphabet is a useful system for manual retrieval of stored information and a useful memory device. Anything that has been named or can be placed in a category can be alphabetized. The alphabet assumes spoken language and is the basic code for written language, although in English phoneticism is chaotic.

In my Performance piece "ABCDEFGHIJKLMNOPQRSTU VWXYZ" (ALPHABET), I have imposed an arbitrary system upon twenty-six activities that have been suggested by the letters of the alphabet. Each section is introduced by the identical and therefore repeated musical theme. The sections are related to each other as they are related to the overall alphabet system and by certain cross-references.

A: "Animals" (film) and eating an apple. B: Bouncing a blue basketball. C: Counting the audience. D: Dance and

dream. E: Egg. F: Unzipping my fly and pulling out six yards of red ribbon, slowly. G: Guessing. H: Hoping ("homosexuality"). I: Iceland, Eisenhower, isosceles, etc. J: Jumping rope. K: Kicking a kite and meowing. L: Tearing out pages from my book *Luck,* arranging them in a grid, then reading one page by chance. M: Matches. N: Nothing. O: Oedipus and riddles. P: Playing the piano. Q: Questions. R: Repeat or Rainbow. S: Singing. T: Traffic. U: Removing my underwear. V: Video film. W: Waltzing. X: X'ing out screen. Y: Yelling. Z: Zoo (film).

ADRIAN PIPER

*Three Models of Art Production Systems**

Key

 (I) — any sensory, intellectual, or otherwise experiential
 information input.

 (C) — any active consciousness that discriminates, quali-
 fies, adds to, interprets, alters, and utilizes (I).

 (P) — the product (e.g., thought, action, idea, object,
 event, etc.) of (I) → (C). An art product (P_a) is de-
 fined as any product (P) that is presented in an art
 context.

 → — is transformed into

* From catalogue of "Information" Exhibition, Museum of Modern Art,
July 2–September 20, 1970.

System I
$(I) \rightarrow (C) \rightarrow (P_a)$ \qquad (P_a) is a separate and final stage in the production process. (P_a) has a physical and/or temporal existence that is qualified by but external to $(I) \rightarrow (C)$.

System II
$(I) \rightarrow (C; P_a) \leftarrow$ \qquad (P_a) is a final stage within the domain of (C). (P_a) properly has internal existence only, which is conveyed through external communication forms, e.g., language, plans, photos, etc.

System III
$(I; P_a) \longleftrightarrow (C)$ \qquad (P_a) is any particular (I) condition. (P_a) has a physical and/or temporal existence, which is unqualified but recognized and distinguished by (C).

In each of the above systems, $(I) \rightarrow (C)$ is antecedent, (P) or (P_a) a transitive consequent. Other models may be constructed using the same four components in varying functional positions.

This exposition uses System II.

3/70

MEL RAMSDEN

The content of this painting is invisible; the character and dimension of the content are to be kept permanently secret, known only to the artist.

Secret Painting. 1967–68.

Abstract Relations. 1968. Title page. →

ABSTRACT RELATIONS.

EDWARD RUSCHA DISCUSSES HIS PERPLEXING PUBLICATIONS*

"I—when I am planning a book, I have a blind faith in what I am doing. I am not implying I don't have doubts, or that I haven't made mistakes. Nor am I really interested in books as such, but I am interested in unusual kinds of publications. The first book came out of a play with words. The title came before I even thought about the pictures. I like the word "gasoline" and I like the specific quality of "twenty-six." If you look at the book you will see how well the typography works—I worked on all that before I took the photographs. Not that I had an important message about photographs or gasoline, or anything like that—I merely wanted a cohesive thing. Above all, the photographs I use are not "arty" in any sense of the word. I think photography is dead as a fine art; its only place is in the commercial world, for technical or information purposes. I don't mean cinema photography, but still photography, that is, limited edition, individual, hand-processed photos. Mine are simply reproductions of photos. Thus, it is not a book to house a collection of art photographs—they are technical data like industrial photography. To me, they are nothing more than snapshots."

. .

"Many people buy the books because they are curiosities. For example, one girl bought three copies, one for each of her boyfriends. She said it would be a great gift for them, since they had everything already."

. .

"I have eliminated all text from my books—I want absolutely neutral material. My pictures are not that interesting, nor the subject matter. They are simply a collection of "facts"; my book is more like a collection of Ready-mades."

. .

"All my books are identical. They have none of the nuances of the hand-made and crafted limited edition book. It is almost worth the money to have the thrill of seeing 400 exactly identical books stacked in front of you."

* Excerpts from interview with John Coplans, *Artforum* (February, 1965).

Various Small Fires and Milk. 1964.

9171 9169 9165 9163 9161 9159 9157

9176 9172 9170 9168 9164 9162 9160

9151 9155 9145

9158 9156 Carol

Edward Ruscha: *Every Building on Sunset Strip.* 1966. Excerpt.

Neutron Emission from Muon Capture in Ca⁴⁰. 1968.

*Canonical Form Factors and Current
Commutation Relations. 1967. Lecture on tape.*

After having executed my first works presenting High School Mathematics, Physics, Chemistry, and Industrial Design (1966), I decided in 1967 on the disciplines I would exploit for the following four years:

— Astrophysics ·
— Nuclear Physics · 1967
— Space Sciences ·

— Mathematics by Computation ·
— Meteorology · 1968
— Stock Market ·

— Meta-mathematics ·
— Psychophysics (Psychochronometry) · 1969
— Sociology and Politics ·

— Meta-mathematics again.
 (Mathematical Logic) · 1970

For each discipline, an expert advised me on the subjects to be presented. Those subjects were selected by their *Importance.*

I did not present Mathematics as Art; but Mathematics as Mathematics.

Bernar Venet: *Information Theory.* 1970.
Title and Contents pages.

INFORMATION THEORY

ROBERT ASH

University of Illinois
Urbana, Illinois

INTERSCIENCE PUBLISHERS
a division of John Wiley & Sons
New York · London · Sydney

CONTENTS

BERNAR VENET, January 9, 1971*

Art only exists on the level of creation. Creation only appears at the moment of true historical contribution. After this, the artist's activity ends up being a production of variations extraneous to the problems of art.

Just as artist "Y" can copy artist "X" who has created a work of historical importance, so artist "X" can also copy his own period of creation. Both cases are useless, sterile efforts and the resulting work does not merit consideration as art.

I do not present my work as art, but I present mathematics and other scientific disciplines for what they are, i.e., pure knowledge as such. My proposition is: Cultivez-vous, Exploitez-vous, Eliminez-vous. (Educate yourself, Exploit yourself, Eliminate yourself.) I have set myself a four-year work schedule, which is coming to an end. Then I have to stop my work as an artist. I have no other choice in the matter.

* In conversation with the editor.

Title page. 1969.

INTERSCIENCE TRACTS
IN PURE AND APPLIED MATHEMATICS

Editors: L. BERS · R. COURANT · J. J. STOKER

Number 21

MATHEMATICAL STRUCTURES OF LANGUAGE
By Zellig Harris

MATHEMATICAL
STRUCTURES
OF LANGUAGE

ZELLIG HARRIS

University of Pennsylvania
Philadelphia, Pennsylvania

INTERSCIENCE PUBLISHERS
a division of John Wiley & Sons New York London Sydney Toronto

INTERSCIENCE PUBLISHERS
A DIVISION OF JOHN WILEY & SONS, NEW YORK · LONDON · SYDNEY · TORONTO

A Wall Stained with Water. 1969.

LAWRENCE WEINER, October 12, 1969*

I do not mind objects, but I do not care to make them.

The object—by virtue of being a unique commodity—becomes something that might make it impossible for people to see the art for the forest.

People, buying my stuff, can take it wherever they go and can rebuild it if they choose. If they keep it in their heads, that's fine too. They don't have to buy it to have it—they can have it just by knowing it. Anyone making a reproduction of my art is making art just as valid as art as if I had made it.

Industrial and socioeconomic machinery pollutes the environment and the day the artist feels obligated to muck it up further art should cease being made. If you can't make art without making a permanent imprint on the physical aspects of the world, then maybe art is not worth making. In this sense, any permanent damage to ecological factors in nature not necessary for the furtherance of human existence, but only necessary for the illustration of an art concept, is a crime against humanity. For art being made by artists for other human beings should never be utilized against human beings, unless the artist is willing to renounce his position as an artist and take on the position of a god. Being an artist means doing a minimum of harm to other human beings.

Big egocentric expensive works become very imposing. You can't put twenty-four tons of steel in the closet.

If art has a general aspect to it and if someone receives a work in 1968 and chooses to have it built, then either tires of looking at it or needs the space for a new television set, he can erase it. If—in 1975—he chooses to have it built again—he has a piece of 1975 art. As materials change, the person who may think about the art, as well as the person who has it built, approach the material itself in a contemporary sense and help to negate the preciousness of 1968

* In conversation with the editor.

materials . . . I personally am more interested in the *idea* of the material than in the material itself.

Art that imposes conditions—human or otherwise—on the receiver for its appreciation in my eyes constitutes aesthetic fascism.

My own art never gives directions, only states the work as an accomplished fact:

> The artist may construct the piece;
> the piece may be fabricated;
> the piece need not be built.
>
> Each being equal and consistent
> with the intent of the artist
> the decision as to condition
> rests with the receiver upon the
> occasion of receivership

1) "The Arctic Circle Shattered"
 Collection of Lucy R. Lippard
2) *Two Minutes of Spray Paint Directly upon the Floor from a Standard Aerosol Spray Can*
 Collection of Mr. Sol LeWitt
3) *An Object Secured upon a Boundary*
 Courtesy Wide White Space, Antwerpen
4) *1,000 German Marks Worth Medium Bulk Material Transferred from One Country to Another*
 Courtesy Konrad Fischer, Düsseldorf
5) *A Turbulence Induced Within a Body of Water*
 Collection of Mr. and Mrs. Van Eelen, Amsterdam
6) *A Square Removal from a Rug in Use*
 Collection of Mr. Wolfgang Hahn, Köln

Lawrence Weiner: *A 36" x 36" Removal to the Lathing or Support of Plaster or Wallboard from a Wall.* 1967.

IAN WILSON, November 12, 1969*

I would like you to tell me about your idea of Oral Communication as an art form. Would you prefer giving me a statement or having a discussion?

I find a discussion form preferable. The fact of a discussion might be more important than what I have to say.

Maybe you could start at the beginning and tell me how you came to think of oral communication as an art form.

It occurred to me when I looked at a Robert Morris sculpture it would be possible for me to say it, to describe it quite easily. I went away thinking that it was not necessary for me to see that sculpture again, I could just say it—not even say it—but think it. It was so primary, so reduced to one unit.

You could experience it thinking of it.

Well, when someone says to you: I am working with a cube, you know exactly what he is talking about. You hold the essence of the idea in your head. It's just like someone saying: I am thinking of God—that's as close as you will ever get to it—you have the essence of the idea. My next step was simply to realize my interest in speech as a medium —first of all—of communication and secondly as the object of communication.

Is oral communication an art form per se or an art form relating to other art forms?

Perhaps I can clarify it by using a Wittgenstein analogy. He found a report in a newspaper in which a model had been used to help a jury decide on a motor accident. Because of this, he was inspired to say or to write: a proposition is a picture of a state of affairs—as the model was the picture of the accident. If you take it a little further and think of the other forms of propositions, one would use to picture the state of affairs of the accident, you could have a written statement, you could have a model, you could take the jury to the place of the accident and have them

* In conversation with the editor.

watch a rerun using similar cars and people or, if you were able and magical enough to turn back time, you could have the whole thing happen once again. The thing about these four propositions is that each one is complementary to the others. But the final one—if it were possible—is the most essential of the four. This is what I am after when I use oral communication as an art form.

Then oral communication is the art itself? There is a difference between the act of oral communication and the object it concerns?

Any discussion, any oral communication, is an example of the object of my thought or the object that I am trying to communicate to you. When I say, I am using oral communication as an art form, I am not only using it at this moment, but I am using whatever other oral communication we might come in contact with in our future or we might remember in our past. What I am trying to do is to direct your attention to the idea and activity. Though the carriers are physical, their thought-object is not and therefore becomes an easily transported experience.

REFERENCES

2–3 Vito Acconci: *Step Piece.* 1970. Courtesy John Gibson Commissions, Inc., New York. Photographs: Kathy Dillon.

4–5 Vito Acconci: *Hand in Mouth Piece.* 1970. Courtesy John Gibson Commissions, Inc., New York.

6–7 Vito Acconci: *Learning Piece.* 1970. Performance (voice and recorded song) at Wadsworth Atheneum, Hartford, Connecticut. Courtesy John Gibson Commissions, Inc., New York. Photograph: Bernadette Mayer.

8 Terry Atkinson and Michael Baldwin: *Map.* 1967. Photograph: Courtesy of the artists.

26 David Bainbridge and Harold Hurrell: *Loop.* 1967. Courtesy Icon Gallery, Birmingham, England.

32 John Baldessari: *Cremation Piece.* 1969. "Software" Exhibition, 1970. Courtesy The Jewish Museum, New York.

34 Robert Barry: *Inert Gas Series.* 1969. Helium; 2 cu. ft. to indefinite expansion, Mojave Desert. Photograph: Courtesy of the artist.

42–43 Frederick Barthelme: *Substitution 20–26.* 1970. Excerpts. "Conceptual Art and Conceptual Aspects" Exhibition, 1970, at The New York Cultural Center, New York.

44–45 Gregory Battcock: *Art I Am Not.* 1970. "Art in the Mind" Exhibition, 1970. Edited by Athena T. Spear. Allen Art Museum, Oberlin College, Oberlin, Ohio. Photograph: Courtesy of the artist.

46–48 Bernhard and Hilla Becher: *Anonymous Sculpture, Cooling Towers.* 1961–70. "Information" Exhibition, July–September, 1970. Courtesy The Museum of Modern Art, New York.

49 Bernhard and Hilla Becher: *Houses* (*Fachwerkhäuser*). 1959–64. Houses in the mine district of South Westphalia. Courtesy Galerie Konrad Fischer, Köln.

51 Mel Bochner: *Compass Orientation.* 1968. White tape letters on floor. Installation at Ace Gallery, Los Angeles, California.

58 Mel Bochner: *Eight Sets "4-Wall."* 1966. Black ink on paper. 8½" x 11". Courtesy of the artist.

59 *Measurement Series: Group "C."* 1967. Black tape on wall, plant, lights. 9' x 9' x 4'. Installation shot at Finch College Museum, New York, 1960. Collection of Robert Rauschenberg.

60 Daniel Buren: *Sandwichmen.* Paris, 1968. Courtesy Galerie Konrad Fischer, Köln. Photograph: Bernard Boyer.

78 Victor Burgin: *Photopath.* 1969. Photographs of the floor, printed to actual size, are stapled to the floor. Photograph: *Studio International,* Vol. 178, No. 915 (October, 1969).

188 Bruce Nauman: *Holographic.* 1968.
 Holograms (Making Faces). 1968. Holographic images on glass. Courtesy Leo Castelli Gallery, New York.

189 *Come Piece.* 1969. Two TV cameras, telephoto lens, two monitors. Courtesy Leo Castelli Gallery, New York.

190 Bruce Nauman: *Bound to Fail.* 1967–70. Color photograph. 19¾″ x 23¾″. Courtesy Leo Castelli Gallery, New York. Photograph: Eric Pollitzer.

191 *Drill Team.* 1966–70. Color photograph. 19½″ x 23¾″. Courtesy Leo Castelli Gallery, New York. Photograph: Eric Pollitzer.

193 Carl Andre: *ACT #83—Unmodified Rock Pile in Colorado and Shape of Rock in Flight* (note arrow). 1968. Courtesy of the artist.

194 N.E. Thing Co. (Iain Baxter): *ACT #113—Xerox Telecopier II and Whole Concept of Transceiving.* 1969. "Conceptual Art and Conceptual Aspects" Exhibition, 1970, at The New York Cultural Center, New York.

195 N.E. Thing Co. (Iain Baxter): *Paint into Earth.* 1969. From N.E. Thing Co. catalogue. Exhibition in The National Gallery of Canada, Ottawa, June–July, 1969.

196–197 Dennis Oppenheim: *Energy Displacement—Approaching Theatricality.* 1970. Documentation. 30″ x 40″. Courtesy John Gibson Commissions, Inc., New York.

198–199 Dennis Oppenheim: *Parallel Stress,* Parts I and II. 1970. Photographs. 40″ x 50″. Courtesy John Gibson Commissions, Inc., New York.

200 John Perreault: *Alphabet.* 1971. Performance at Emanu-el Midtown YM-YWHA, New York, January 31, 1971.

204 Mel Ramsden: *Secret Painting.* 1967–68. Photograph: Courtesy of the artist.

205 *Abstract Relations.* 1968. Title page. Photograph: Courtesy of the artist.

206 Edward Ruscha: *Various Small Fires and Milk.* 1964. Excerpts from book.

208–209 Edward Ruscha: *Every Building on Sunset Strip.* 1966. Reproduction excerpted from book.

210 Bernar Venet: *Neutron Emission from Muon Capture in Ca^{40}.* Courtesy of the artist. Photograph: Peter Moore.

211 *Canonical Form Factors and Current Commutation Relations.* 1967. Lecture on tape. Photograph: Courtesy of the artist.

213 Bernar Venet: *Information Theory.* 1970. Title and Contents pages. 101″ x 61″. From *Flashart Magazine* (November–December, 1970).

215 Bernar Venet: *Mathematical Structures of Language.* 1970. Title page and facing page. Courtesy Galerie Daniel Templon, Paris.

216 Lawrence Weiner: *A Wall Stained by Water.* 1969. Installation shot at the Ace "Wall Show"—Part I, 1969. Courtesy Ace Gallery, Los Angeles, California.

219 Lawrence Weiner: *A 36" x 36" Removal to the Lathing or Support Wall of Plaster or Wall Board from a Wall.* 1967. Collection of Seth Siegelaub, New York.

Reprinted by permission of the publisher from... [illegible faded text]